THE **TOLSTOYS** IN THE 21ST CENTURY

The publication of *The Tolstoys in the 21st Century* has been made possible
by the generous support of Jostein Eikeland

OLEG TOLSTOY

THE **TOLSTOYS** IN THE 21ST CENTURY

Texts by Rosamund Bartlett, Edward Lucie-Smith and Ekaterina Aleksandrovna Tolstaya

MERRELL
LONDON · NEW YORK

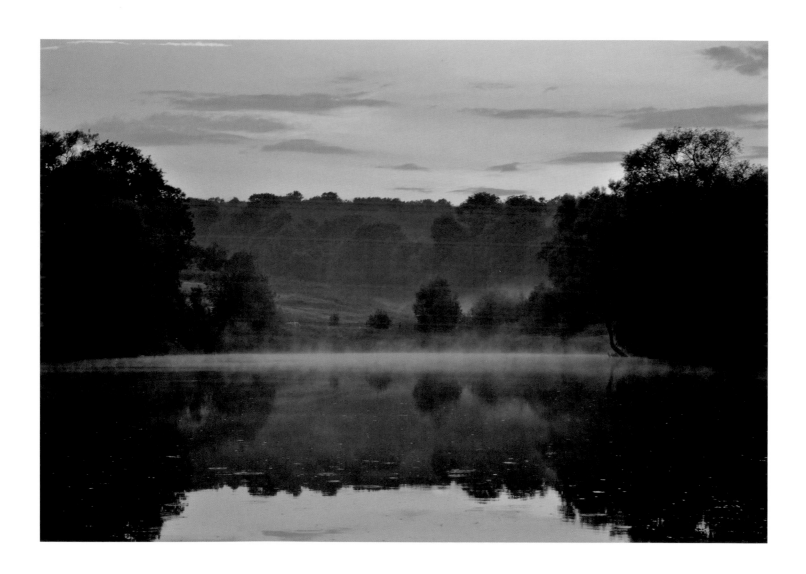

Contents

Preface
Oleg Tolstoy

The Tolstoys in the 21st Century is a photographic study of eighty-two descendants and relatives of Lev (Leo) Tolstoy who attended the biennial family reunion at Tolstoy's country estate in 2012. My original aim was to explore my family heritage by taking portraits of my relations. It was a personal investigation into who I am.

My full name is Count Oleg Andreevich Tolstoy-Miloslavsky. I am a descendant of the Russian noble family Tolstoy and the ancient Russian boyar family Miloslavsky. Count Lev Nikolayevich Tolstoy (1828–1910), author of *War and Peace* and many other literary masterpieces, is the most illustrious member of our family. My common ancestor with Lev Tolstoy is Andrey Vasilyevich Tolstoy, who in 1642 married Solomonida Miloslavskaya. It was by reason of this marriage that our two names were joined together. Solomonida's cousin Maria Miloslavskaya married the Russian tsar Alexey Mikhailovich Romanov (reigned 1645–76).

Following the Bolshevik Revolution in 1917, my grandfather Dmitry Mikhailovich was forced to flee his homeland. In 1918 he arrived as a refugee in England, where he married twice. His four children and all his grandchildren (including me) were brought up in England.

The idea for this project originated from a previous project of mine. At university I decided I wanted to learn

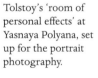

Tolstoy's 'room of personal effects' at Yasnaya Polyana, set up for the portrait photography.

more about Russia, the country of my forebears. I asked my father, who has worked in Russia since 1988, if he could find a way to contact Boris Mikhailov, who was my favourite photographer at the time. Mikhailov's photographs captured the collapse of the Soviet Union. Meeting him, studying his images and writing my dissertation on his work enabled me to gain an understanding of the post-Soviet era. In fact, it was Mikhailov who suggested that I take on a project about my family.

The portraits were taken at Yasnaya Polyana, the Tolstoy family estate, near the city of Tula. Since the year 2000 Yasnaya Polyana has hosted the Tolstoy family reunions, when some 100 Tolstoy descendants and relatives from all over the world – mainly Russia, Europe and North America – gather together for a week. The reunion includes optional activities for each day of the week. In 2012 the portrait-sitting formed part of the programme. Eighty-two portraits were taken over the course of four days. The photographs in this book are arranged in genealogical order (see the note on p. 28).

Each participant was asked to complete a form with their personal details and a few words about themselves and how they felt about being a descendant or relative of Lev Tolstoy. Many mentioned, for example, an 'incredible sense of pride' and privilege in belonging to the Tolstoy family. One participant believed that the family name had given him a 'wonderful sense of security … and self-assurance'; others felt a sense of responsibility to their 'distinguished origins'. A few relatives living outside Russia commented on the Russian family traditions they have inherited and their 'connection with Russia', and expressed gratitude for their 'wonderful extended family'. Others thought that their family ties had made a greater impact, making such comments as 'I am strongly affected by awareness of our family's long, varied and distinguished history', 'Learning about Tolstoy teaches me about life', and 'I hold [Lev Tolstoy's] accomplishments as a standard for which I should strive.'

I had previously visited Yasnaya Polyana when I was seven years old and had always longed to revisit. During the reunion the guests stay in a nearby hotel run by the estate. The portraits were taken in the house – in Tolstoy's 'room of personal effects' (see opposite), next to the bedroom of his wife, Sofya. The room, lined with large glass cabinets filled with Tolstoy's clothing and accessories, was closed to the public for a week. Each sitter entered the house through a back door (an entrance not used by the public), then went up a short flight of stairs for their five-minute sitting. Although some of my immediate relatives – my father, brother, uncle and three cousins – were at the reunion, this was the first opportunity I had to meet my wider family.

My intention was to present the portraits as simply as possible, while applying a classical portrait-painting style. My inspiration was the 1873 painting of Tolstoy by Ivan Nikolayevich Kramskoy, a copy of which hangs in my grandparents' home and in the dining room at Yasnaya Polyana (see pp. 12–13; the original is in the State Tretyakov Gallery in Moscow).

Since members of the public are not permitted to take photographs inside the house, I felt extremely privileged to set up my portrait studio in Tolstoy's home. During the course of the photo sessions, it became clear to me that it was important to each sitter that their portrait was taken inside Tolstoy's home; it was an opportunity to put their own stamp on the place in some way. I do not think the project would have commanded the same significance had I not been able to photograph inside the house. Certainly, the participants were acutely aware of the unique location and occasion – an honour that added to the celebration of being part of the Tolstoy family.

Tolstoy's Home at Yasnaya Polyana

Ekaterina Aleksandrovna Tolstaya

Lev Tolstoy was born at his family's country estate, Yasnaya Polyana, in 1828. It was here that Tolstoy spent most of his life, and it is where he wrote his literary masterpieces and where he was buried (see p. 11). Tolstoy chose his burial place himself: the Stary Zakaz woods, a site connected to the story of his brother Nikolay's magical 'green stick' (Nikolay claimed that the stick bore the secret to universal happiness).

The year 1921 saw the opening of a museum at Yasnaya Polyana – a place dedicated solely to sharing and promoting Tolstoy's creative legacy. One of Russia's most important cultural heritage sites, it also holds a proud place among the most remarkable memorial museums in the world. Today Yasnaya Polyana is a large museum complex, recognized as a cultural centre of international significance. Although the museum now comprises a whole network of branches in various locations, it is the outstandingly beautiful estate that remains at its heart. Yasnaya Polyana has been preserved almost exactly in its original state, just the way Tolstoy knew and loved it. A good many countryside traditions persist to this day: apples are picked in the Tolstoy family orchards, the aviary continues to flow with golden honey, and the horses that grace the estate are still a sight to behold. Not only does Yasnaya Polyana look just as it did in Tolstoy's day, it also retains the spirit of his times.

The front of the house at Yasnaya Polyana, where Lev Tolstoy spent most of his life.

An avenue of birch trees leads from the gate of the Yasnaya Polyana estate to the house.

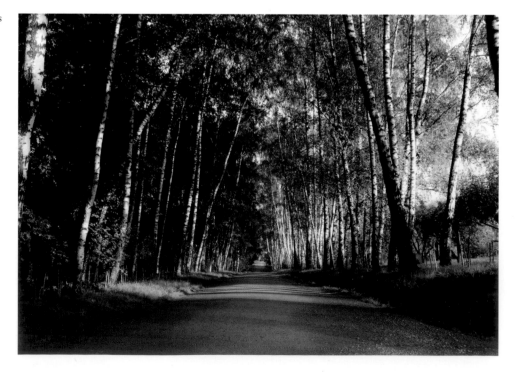

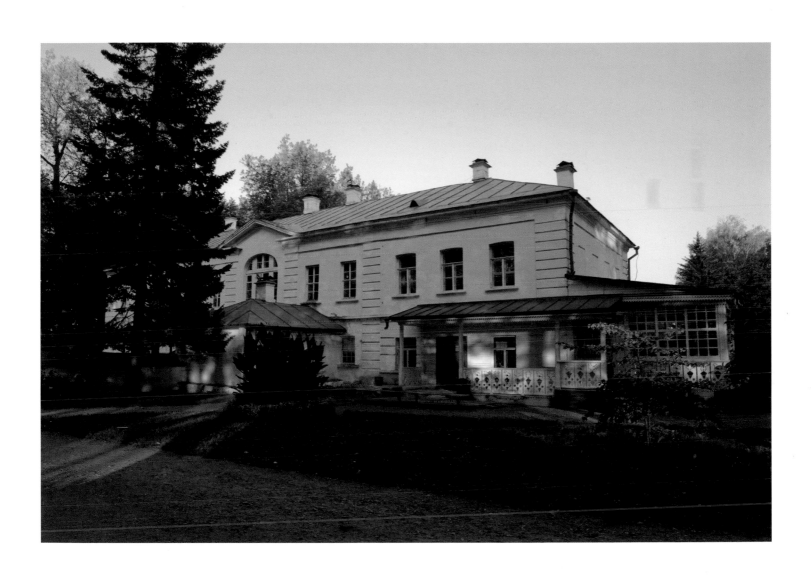

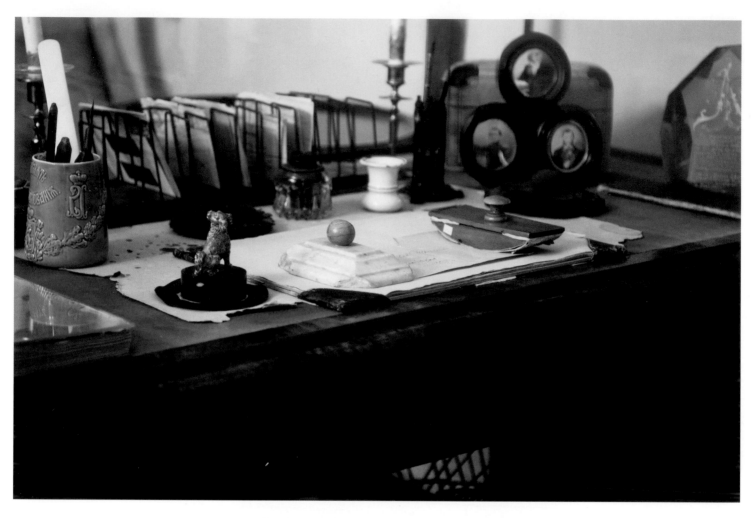

Tolstoy wrote most of his works, including *War and Peace* and *Anna Karenina*, at this Persian walnut desk, formerly owned by his father.

Each year the museum is visited by more than 160,000 people, who come to see the exhibits and thoroughly immerse themselves in the world and work of Tolstoy. The museum offers something for everyone: schoolchildren and students, parents with young children, and members of the older generation can all gain inspiration from the surroundings. Thanks to its accessibility and relative proximity to Moscow (Yasnaya Polyana is located in the Tula region, some 200 kilometres/125 miles from the capital), a large number of foreign visitors are also able to experience the museum.

Descendants of Lev Tolstoy visited Yasnaya Polyana throughout the Soviet era, but the idea of regular family gatherings would have been out of the question at that time. Then, in 1991, several generations of the Tolstoy family, including members living abroad, arranged to meet at the country estate.

The year 2000 saw the first large reunion of the writer's descendants, and the event is now a regular occurrence, taking place every second year. These gatherings are hugely worthwhile in terms of maintaining links across the large Tolstoy family, and they also exemplify the importance and value attached to family traditions in general.

Tolstoy family reunions are held in late summer and last about a week. The participants enjoy a rich programme of cultural events and performances, all revolving around a particular topic or theme, depending on the significance of the year: for example, it could be a significant anniversary of the birth or death of Lev Tolstoy or his wife, Sofya Tolstaya, or an anniversary of their wedding, or of the birth of one of their children. The programme includes a visit to Yasnaya Polyana and other country and city estates of the Tolstoy

family; exhibitions and lectures relating to the family's history; and workshops and masterclasses devoted to the traditional leisure pursuits of the Tolstoys, as well as reconstructions of historical events. Most importantly, the reunions provide an opportunity for conversation and the building of cross-cultural ties. The Tolstoy family home welcomes the writer's descendants and relatives from all over the world: from Russia, France, Germany, Great Britain, the Czech Republic, Sweden, the United States and South America.

These events not only create lasting memories for the family members involved, but also serve to enrich the archives of the Yasnaya Polyana museum. The museum's photographic collection contains over 4000 items (daguerreotypes, prints, negatives and slides) dating from the 1850s to the present day. The images depict the life of Lev Tolstoy and his family, and their relatives, friends and acquaintances, as well as the work of the museum – its visitors, festive occasions and the many exhibitions and academic conferences.

The portraits in this book were all taken at the family reunion at Yasnaya Polyana in 2012. More than eighty descendants and relatives of Lev Tolstoy were each photographed by fellow relative Oleg Tolstoy-Miloslavsky in Tolstoy's 'room of personal effects', and – as Oleg reports – many found it to be a moving, deeply personal experience. Although members of the modern-day Tolstoy dynasty live in many countries across the globe, Yasnaya Polyana is where they can truly reconnect with their Russian heritage; it is the one place that unites us all.

Tolstoy's grave in the Stary Zakaz woods, within the grounds of the Yasnaya Polyana estate.

Overleaf:
The dining room at Yasnaya Polyana is home to several family portraits. From left to right: Maria Tolstaya, the second daughter of Lev Tolstoy, by Nikolay Ge; Lev Tolstoy by Ivan Kramskoy; Tatyana Tolstaya, the eldest daughter of Lev Tolstoy, by Ilya Repin; Lev Tolstoy by Ilya Repin; Sofya Tolstaya, Lev Tolstoy's wife, by Valentin Serov.

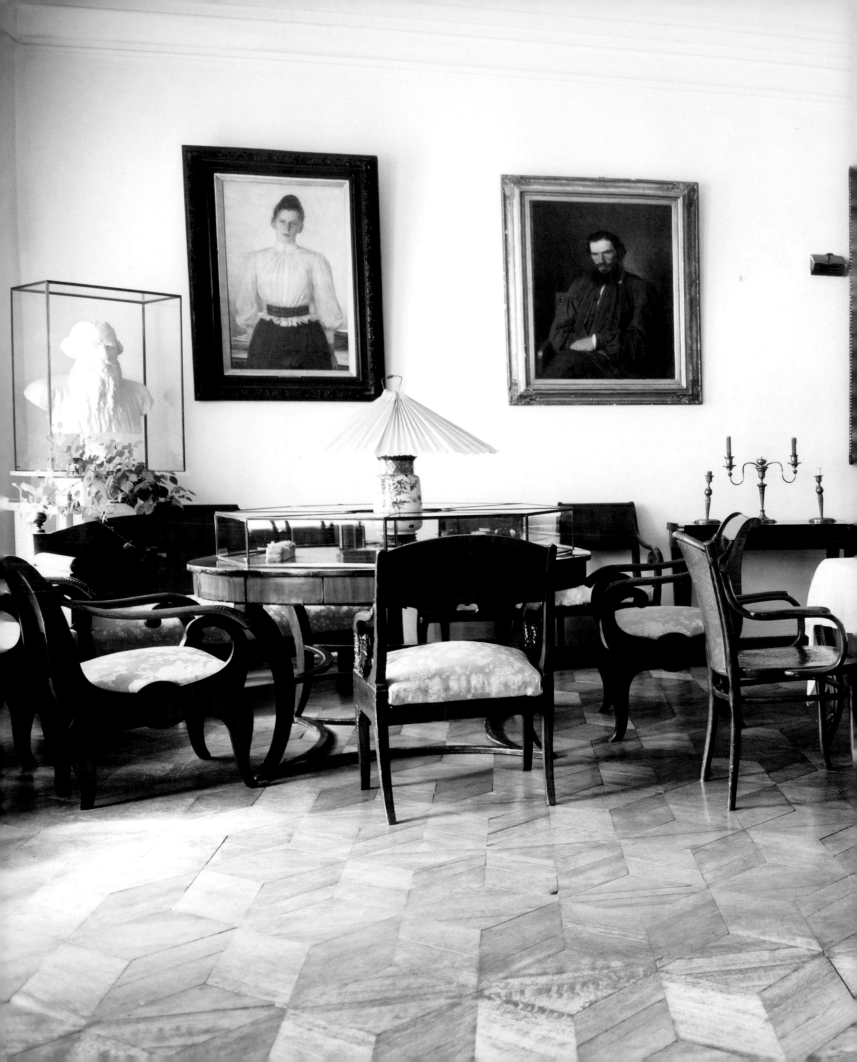

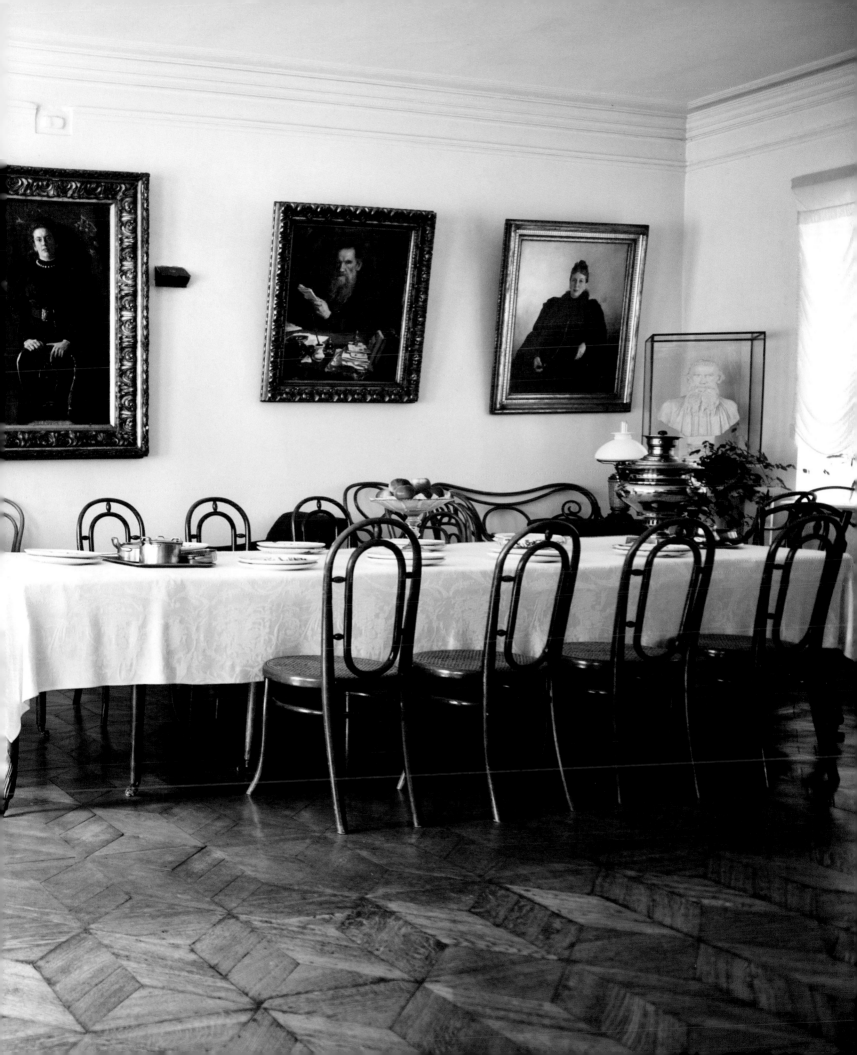

A Genius in the Family
Edward Lucie-Smith

It is not surprising that people take a keen interest in not only the actual lives of great creative artists, but also their posterity and especially their descendants who happen to be living in our own time. We want to know if the characteristics of these illustrious forebears have been inherited. Even more, when we meet one of the descendants of a genius, we somehow feel that we have been in touch with the genius him- or herself.

This is particularly the case with great writers, major figures who now seem to posterity to have both defined and shaped the cultures into which they were born. Great musicians and great painters and sculptors do not seem to arouse quite this same degree of interest, although there are a few exceptions.

Writers from before the nineteenth century with traceable posterity are, however, rare. Shakespeare, for example, had three children with his wife, Anne: a daughter named Susanna, born in 1583, and twins named Judith and Hamnet, born in 1585. Hamnet, his only male offspring, died in 1596, aged eleven. Susanna had one child, a daughter, who married twice but never produced children. Judith, the younger sister, produced three sons. One died in infancy. The other two reached adulthood, but both died in 1639, unmarried and childless.

The nineteenth century was pre-eminently an era of great novelists, Lev Tolstoy extremely prominent in their ranks. It is therefore particularly interesting to look at their descendants, if any, not least because the novelist is a writer who attempts to create a complete social universe, peopled, very often, by a complex array of characters. As is the case with those who shone in other areas of artistic creativity, some major novelists have descendants still living today, and some do not.

Victor Hugo died in 1885. His best-known twentieth-century descendant was a great-grandson, the artist Jean Hugo (1894–1984), who was closely linked to the Surrealist movement. With his wife Valentine Gross, Jean Hugo created scenery and costumes for some of the plays of Jean Cocteau. Other descendants are still active today. The year 2007 saw the conclusion of a six-year battle in the French courts: the great-great-grandson of the novelist attempted, and failed, to ban a modern sequel to *Les Misérables* (1862). The battle pitched the concept of an author's 'moral rights', considered timeless in French law and passed on to descendants, against French copyright law, which puts any literary work in the public domain seventy years after the author's death.

Other major French novelists did not leave children or grandchildren. Honoré de Balzac fathered an illegitimate daughter, who was never fully acknowledged. In 1832 he received an anonymous letter from Ewelina Hanska, the young wife of a wealthy Polish landowner then living in Odessa.

Balzac managed to discover who she was, and they embarked on a nine-year correspondence. Hanska's much older husband died in 1841, and in 1843 Balzac went to visit her in St Petersburg. After overcoming various obstacles, among them the disapproval of the tsar, they finally married in March 1850, in the Ukraine, and set out for Paris at the end of the following month, arriving there on 20 May, Balzac's fifty-first birthday. He was already in extremely poor health. He died the following August, five months after the wedding. The couple had no children.

Another great French novelist who died childless was Gustave Flaubert, who never married. He is reported to have had only one romantic relationship, with the poet Louise Colet, and otherwise contented himself with visiting prostitutes. During his travels in the Near East – Lebanon and Egypt – he frequented male prostitutes as well as female ones, and made no particular secret of the fact. Not surprisingly, Flaubert suffered from a variety of venereal diseases before his death at the age of fifty-eight.

Two iconic nineteenth-century American authors, Herman Melville and Mark Twain, helped to form America's vision of itself, and also the outside world's vision of America, in much the same way that Tolstoy and one or two other Russian writers of the same epoch formed our vision of the Russian genius. Both married and had children. Melville's wife, Elizabeth, whom he married in 1847, was the daughter of the chief justice of the Massachusetts Supreme Court. They had two sons and two daughters, but only one of the daughters had children, so Melville's descendants all belong to the female line; none carries his surname. Nonetheless, as reported by the *New York Times* in August 1987, 'Dozens of descendants of Herman Melville came from as far away as London and Alaska to celebrate a family reunion at Arrowhead [Mass.], the 19th-century author's Berkshire Mountain home where he wrote *Moby Dick*.'

More recently, Melville's great-great-great-granddaughter Liza Klaussmann has been in the news as a successful novelist. Rather ironically in the circumstances, critics have compared her work not to that of her famous ancestor, but to that of F. Scott Fitzgerald – a writer whose work is about as far from Melville in tone and content as one can conveniently imagine.

Twain (Samuel L. Clemens) also had four children, but only one, his daughter

A bookcase in the 'room for visitors' at Yasnaya Polyana.

Clara, survived him when he died in 1910. Clara in turn had one child, by her first marriage to the Russian-born conductor/composer Ossip Gabrilowitsch. Their daughter, Nina Clemens Gabrilowitsch, born in the year her grandfather died, was an alcoholic who took her life in January 1966 in a Los Angeles hotel room. She was the last of Mark Twain's descendants.

In Britain, one of the major names in the fiction of the Victorian period is that of George Eliot, author of *Middlemarch* (1871–72), which many consider to be the single greatest work of fiction produced in English during the course of the nineteenth century. 'George Eliot' was in fact the pseudonym of a female author, Mary Ann Evans. She lived for many years, from 1854 until his death in 1878, as the companion of a fellow writer, George Henry Lewes, who was unable to obtain a divorce from his wife. The relationship was surprisingly public for its period – never concealed, as was, for example, Dickens's relationship with the actress Ellen Ternan – but the couple did not produce children. In 1880, two years after Lewes's death, George Eliot married a man twenty years her junior. They honeymooned in Venice, and, in a fit of depression, her new husband, John Cross, attempted suicide by jumping from their hotel balcony into the Grand Canal. George Eliot was already sixty when they married; she died at the end of the same year, after their return to London.

Charles Dickens did, by contrast, leave descendants who are still living today. On 7 February 2012, 160 of them gathered in London to celebrate the bicentenary of the novelist's birth. *The Telegraph* reported: 'They're an impressive bunch, the Dickenses. Charles had 10 children and over the years they have produced a smattering of admirals, high court judges, businessmen, writers and actors, and have spread across the world to South Africa, Australia and California.'

In Russia, the great novelistic names we immediately think of are Turgenev,

Dostoyevsky and – of course – Tolstoy. Ivan Turgenev did not produce a family. He never married, but in his youth had an illegitimate daughter named Paulinette, whose mother was a serf. There seems to be no record of Paulinette's descendants, if any. The major emotional event of Turgenev's life was his long relationship with the celebrated French opera singer Pauline Viardot. Viardot was married to a successful impresario, with whom she had four children, all of whom became professional musicians. Turgenev met her in St Petersburg in 1843, three years after her marriage, and immediately fell in love with her after hearing her sing the role of the heroine – the delightful Rosina – in Rossini's *Barber of Seville*. He followed her back to France and installed himself in the Viardot household, where he treated her children as his own, but it is doubtful that their affair was ever consummated. When the household exiled itself to Baden-Baden, on account of the Viardots' opposition to the regime of Napoleon III, Turgenev accompanied them. After they returned to France, following the fall of the Second Empire, Turgenev bought the family a house in Bougival, close to Paris. The Villa Viardot is now a venue for concerts and masterclasses.

Fyodor Dostoyevsky's remoter ancestors were members of a Lithuanian noble house. His father came from a family of Orthodox priests, but rejected this background and trained as a doctor. Eventually he reached a position that gave him legal status as a member of the nobility, and purchased a small estate about 150 kilometres (90 miles) from Moscow, where the family spent its summers. Dostoyevsky was never, as Westerners sometimes suppose from much of his subject matter, a member of the working class.

Dostoyevsky's beginnings as a writer were nevertheless very harsh (in his late twenties he was condemned to death for sedition, reprieved at the last moment, then sent to Siberia), and not helped by

the fact that he suffered from epilepsy. By the end of his life, however, he was celebrated, if still controversial, in Russia and was beginning to be known abroad. His celebrity continued to spread internationally after his death. Sigmund Freud, for example, called *The Brothers Karamazov* (1880) 'the most magnificent novel ever written'.

During the Soviet period Dostoyevsky was widely read in Russia, although also sometimes censored. His books sold more than 34.4 million copies between 1917 and 1981. There are now numerous Russian memorials to Dostoyevsky, plus Dostoyevskaya stations on both the Moscow and St Petersburg metro systems, duly adorned with murals illustrating his books.

Despite his literary reputation, Dostoyevsky's few living relatives have not fared well in post-Soviet society. In June 2003, Mark Franchetti, Moscow-based correspondent of the London *Sunday Times*, reported that 'Dimitry Dostoevsky, 57, and his sister Tatyana, 68, are among the six living relatives of the celebrated 19th-century author of *Crime and Punishment*. Last week Dostoevsky, who earns less than £100 a month as an unlicensed taxi driver [in St Petersburg],

placed an advertisement in a Russian newspaper asking for donations to help him look after his bedridden sister, who survives on an invalidity pension of less than £40 a month.'

Compared both to possible Russian equivalents and to the surviving descendants of great writers using other languages, the family of Lev Tolstoy has shown surprising resilience and powers of self-renewal, as this book of portraits amply demonstrates. The only – not very close – equivalents are the family of Dickens, and perhaps the families of Hugo and Melville, although the latter descends in the female line only.

There is even another writer of some distinction in the Tolstoy lineage, although he came from a different branch: Count Alexey Tolstoy, whose birth in 1882 was attended by a considerable scandal. His mother, two months pregnant, had left her violent husband, a rakehell cavalry officer, and eloped with a lover. The baby was nevertheless officially registered as the son of Nikolay Alexandrovich Tolstoy, and the Tolstoy family accepted this. When Nikolay Tolstoy died in 1900, he left Alexey 30,000 roubles – recognition enough.

After various political vicissitudes – in exile, then back in the Soviet Union –

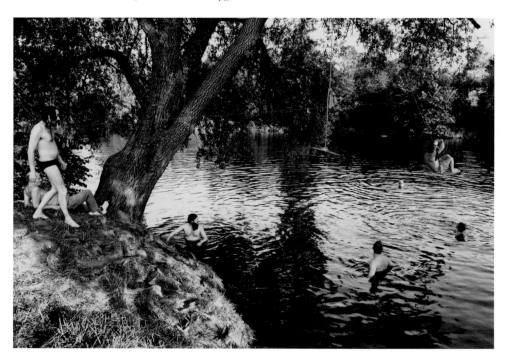

The Tolstoy-Miloslavsky family swimming in the 'Big Pond' on the Yasnaya Polyana estate. That's me, Oleg, on the rope swing. Photograph by Igor Tolstoy-Miloslavsky.

Alexey Tolstoy became a hugely successful author who showed no restraint in grovelling to the new master: 'I want to howl, shriek, bawl with rapture at the thought that we are living in the days of the most glorious, one and only, incomparable Stalin! Our breath, our blood, our life – here take it, O great Stalin.' The 'Red Count', as he became known, escaped Stalin's purges, and lived until 1945. His work – some of it – is still read in Russia.

Lev Tolstoy had thirteen legitimate children. The Russian Revolution scattered those who grew to adulthood to the four winds. Quite a number were linked to the arts. His eldest son, Sergey Lvovich Tolstoy, was a composer, music critic and (like so many Tolstoys) a writer of memoirs. His third son, Lev Lvovich, was a sculptor and again a memoirist. He emigrated to Sweden and turned violently against many of the ideas espoused by his father. Tolstoy's fourth surviving son, Mikhail Lvovich, served in the tsarist army, settled in the United States and died in 1944 in Rabat, Morocco. He had nine children.

The fate of Tolstoy's surviving daughters was equally varied. The eldest, Tatyana, trained as a painter. She was guardian, immediately post-Revolution, of Yasnaya Polyana, the family estate (now a museum), then emigrated to Paris with her daughter, and eventually died in Rome. The youngest daughter, Alexandra, served as her father's secretary and was imprisoned by the Bolsheviks in 1920, but was released and made director of Yasnaya Polyana in 1921. She emigrated in 1929 and settled in the United States, where she established the Tolstoy Foundation. She became an American citizen in 1941. She had no children.

In 1994 the family estate came, yet again, under the directorship of a member of the Tolstoy family – Vladimir Tolstoy (see p. 58). In 2000 he started to organize a series of biennial family reunions, which continue today. It was at one of these gatherings that the photographs in this book were taken. The photographer, Count Oleg Andreevich Tolstoy-Miloslavsky, belongs to a branch of the now widespread Tolstoy family that is in fact senior to that of the great writer. The images are modelled on a famous portrait of Lev Tolstoy painted in 1873 by Ivan Kramskoy and now in the State Tretyakov Gallery in Moscow. There is a copy of the painting in the dining room at Yasnaya Polyana (see pp. 12–13).

Looking at these expressive portraits, one notes a spectrum of nationalities – Italian, Swedish, French, Czech, Canadian and American, as well as Russian. A great-great-grandson is an officer in the United States Marine Corps (see p. 106). A great-great-granddaughter is Director of Communications and Marketing for Amnesty International in Canada (see p. 122). A number of those portrayed have connections with the arts. Vladimir Tolstoy is now Special Adviser on Cultural Affairs to President Putin. The diversity of nationalities reflects the enormous social upheaval created by the Russian Revolution. The fact that the photographs were all taken at Yasnaya Polyana testifies, by contrast, to the continuing strength of the family bond, more than a century after Lev Tolstoy's death.

There is, however, a certain irony in the fact that, at the very end of his life, Tolstoy fled from wife and family, with no particular destination in mind, to finish up at a remote railway station called Astapovo. There he fell ill, dying in a room at the stationmaster's house, since preserved as a museum. At the conclusion of his flight, his last illness became an enormous public event, involving not only members of his family, but also government secret agents, priests hoping for a return to the church Tolstoy had rejected, and a horde of reporters and photographers. Like all great writers, Tolstoy belongs not just to his many descendants and collateral relations, but to everybody.

Many of the direct descendants of Lev Tolstoy who attended the Tolstoy family reunion at Yasnaya Polyana in 2012, with some of their close relatives.

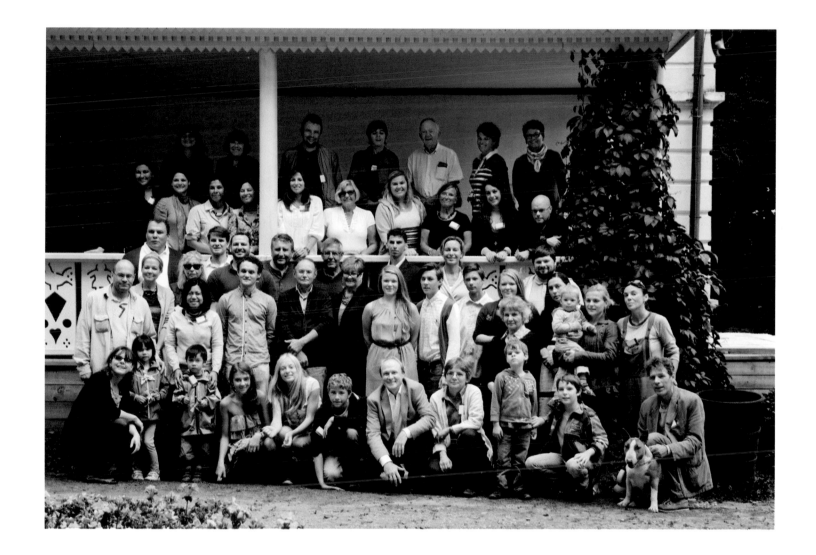

Tolstoy family portraits
in the drawing room at
Yasnaya Polyana.

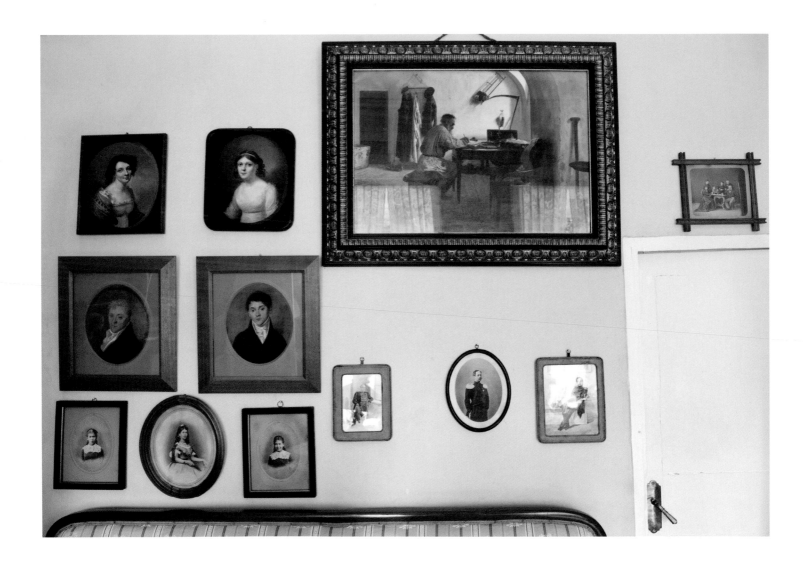

The Tolstoys
Rosamund Bartlett

Even without a world-famous author in their midst, the Tolstoys have always been a force to be reckoned with. With ancestry possibly dating back to the fourteenth century, and more than 300 living descendants dispersed across the globe, the family's scions have included prominent statesmen and military leaders as well as distinguished figures in the arts. And that is to say nothing of the host of flamboyant and unusual individuals whose colourful lives have consolidated the family reputation for eccentricity. The Tolstoys have a complicated genealogy. There is the titled branch and the untitled branch, both of which have senior and cadet lines. There is the Tver branch of the Tolstoys, and also the Kutuzov branch (see pp. 188–91), formed when Praskovya Golenishcheva-Kutuzova, daughter of the famous field marshal, married Matvey Tolstoy. In 1859 Kutuzov's third grandson, Pavel Mikhailovich, was allowed by Alexander II to acquire the rare triple-barrelled surname of Golenishchev-Kutuzov-Tolstoy. Then there are the Osterman-Tolstoys, and the Tolstoy-Miloslavskys (see pp. 166–87), who were given permission by Nicholas II to adopt their double-barrelled surname in 1910. This was to recognize their descent from the female line of the old boyar Ivan Miloslavsky, and to prevent the ancient name from dying out.

The cynosure of this great dynasty, however, is indisputably Count Lev Nikolayevich Tolstoy, the novelist famously hailed by Turgenev as the 'great writer of the Russian land', who belongs to the senior titled branch of the family. Tolstoy's family pedigree meant a great deal to him. The passage in Part Two of *Anna Karenina* in which the old-world Russian noble Levin scoffs at such nouveau riche aristocrats as Vronsky, who lack breeding and cannot point back three or four generations, largely expresses his own sentiments. Whether it is the nostalgic celebration of patriarchal values in *War and Peace*, or the dogged championing of them in defiance of their erosion by the forces of modernity in *Anna Karenina*, one has to turn only a few pages of Tolstoy's great masterpieces of fiction to realize that family is his great theme.

Tolstoy drew as much on his immediate family and forebears to breathe flesh and blood into the iconic characters of his two great novels as he drew on his own troubled personality, and the reassuring surroundings of his ancestral home were always instrumental to his inspiration. Deep in the lush Russian countryside south of Tula, the family estate of Yasnaya Polyana was where Tolstoy was born. It was where he spent seventy of his eighty-two years, and where he lived until his final flight, just a few weeks before his death in 1910. It remained a place of cardinal importance to him throughout his life and is still one of Russia's best-known and most frequently visited museums. In recent years Yasnaya

Polyana has also become a beloved focal point for the large numbers of Tolstoy's descendants who gather there regularly for jubilant family reunions.

Tolstoy family history goes back into the mists of time. According to legend, the Tolstoy dynasty was launched by a German (or a Lithuanian or a Frenchman) called Indros (or Indris). In 1352 he supposedly migrated from the Holy Roman Empire with two sons and 3000 men, settled in Chernigov, changed his name to Leonty and converted to Russian Orthodoxy. Whether this mythical ancestor ever really existed we shall never know, but the Tolstoys can certainly trace their lineage to Andrey Kharitonovich, who brought his family to Moscow in the early fifteenth century. It was Andrey Kharitonovich's round physical shape that apparently earned him the nickname of *tolsty* (the Russian adjective for 'fat'), and this moniker in turn gave rise to the family's illustrious surname of Tolstoy.

In 1682 Russian families were obliged to register their genealogy with the state in order to legitimize their claim to noble status. One of the six signatories who submitted the Tolstoys' early family history to the Russian heraldry office in Moscow in 1686 was the court servant Pyotr Andreyevich (1645–1729). A few decades later he would become the first Count Tolstoy. A man of immense energy with a brilliant mind, he was sent by Tsar Peter I to Italy to study navigation and shipbuilding. On his return to old Muscovy a year and a half later, Pyotr Tolstoy became one of the first Russians to don Western dress. Seeing his remarkable diplomatic potential, Peter then appointed Pyotr Andreyevich to be Russia's first ambassador to Constantinople.

By the time Tolstoy returned to Russia in 1714, thirteen years later, Peter the Great had not only founded St Petersburg, but had also made it his new capital. Tolstoy accompanied the tsar on further foreign trips, and then in 1717 was entrusted

with the most delicate and challenging of missions. He was to go to Naples and persuade Peter's errant son Alexey, the heir to the throne, to return to Russia. Hostile to his father's reforms, Alexey had sought refuge in Vienna with his brother-in-law Emperor Charles VI, who stationed him out of harm's way in Naples in order to avert a diplomatic crisis. Pyotr Andreyevich had to resort to guile and cunning, but his mission was successful. On his return to Russia, the tsarevich Alexey was immediately thrown into the dungeon of the Peter and Paul Fortress and interrogated for treason; he died soon afterwards.

For his role in this affair, Pyotr Tolstoy was showered with riches by the grateful tsar, who decorated him, appointed him senator and gave him extensive lands. By the time he was made a count, on the day of the coronation of Peter's wife Catherine I as empress in 1724, Pyotr Andreyevich was one of the most powerful men in Russia. But his later political machinations were to be his undoing. In 1727, two years after Peter the Great died, he was himself arrested and imprisoned in the Peter and Paul Fortress. At the age of eighty-two, Pyotr Andreyevich was shorn of his title, his decorations and his lands, and sentenced to life exile in the Solovetsky Monastery prison, on an island near the Arctic Circle. With its harsh climate, it was a particularly bleak place to serve a sentence. Pyotr Andreyevich's son Ivan, who accompanied him into exile, died the year after they arrived. Within eight months, Pyotr Andreyevich was also dead.

The Tolstoy family's position improved when Peter the Great's daughter Elizabeth finally became empress. By 1760 she had returned all the Tolstoy family estates to Ivan Petrovich's widow, as well as Pyotr Andreyevich's title. It was at this time that the Tolstoy family crest was designed, consisting of a shield supported by two borzoi dogs, signifying loyalty and swiftness in attaining results. The shield,

divided into seven segments, features at its centre a crossed gold sword and a silver arrow running through a golden key, as a symbol of the family's long history. In the top left-hand corner is half of the Russian imperial eagle, and next to it on a silver background is the blue St Andrew Cross, which Pyotr Andreyevich was awarded in 1722. In the bottom right-hand corner the seven towers topped with crescents recall Pyotr Andreyevich's incarceration in Constantinople's Yedikule Fortress while Russia was at war against the Ottoman Empire, and his role in securing victory.

Ivan Tolstoy's second son, Andrey Ivanovich (1721–1803), was Tolstoy's great-grandfather. Count Andrey Ivanovich Tolstoy, as he now became at the age of thirty-nine, was a loyal servant of the state and fiscally astute. This could not be said about the profligate and sybaritic Ilya Andreyevich (1757–1820), Tolstoy's

grandfather. He and his wife, Pelageya Nikolayevna (1762–1838), lived in some style (the count even dispatched his linen to Amsterdam to be laundered), and it is not hard to see their shadows behind the figures of Count and Countess Rostov in *War and Peace*. Ilya Andreyevich's extravagant lifestyle eventually led him into debt.

Tolstoy's father, Nikolay Ilyich, born in 1794, was the eldest of Ilya Andreyevich's and Pelageya Nikolayevna's four sons. When Napoleon invaded Russia in 1812, Nikolay Tolstoy fought with distinction, but he struggled in civilian life. After all the family debts had been paid off, Nikolay Ilyich was forced to lead a modest life in Moscow and find a job. When Tolstoy describes the position in which Nikolay Rostov finds himself after the death of the old count in *War and Peace*, he is essentially telling the story of his father, who in 1821 took up a very

The bedroom of Sofya Andreyevna Tolstaya, Lev Tolstoy's wife, at Yasnaya Polyana.

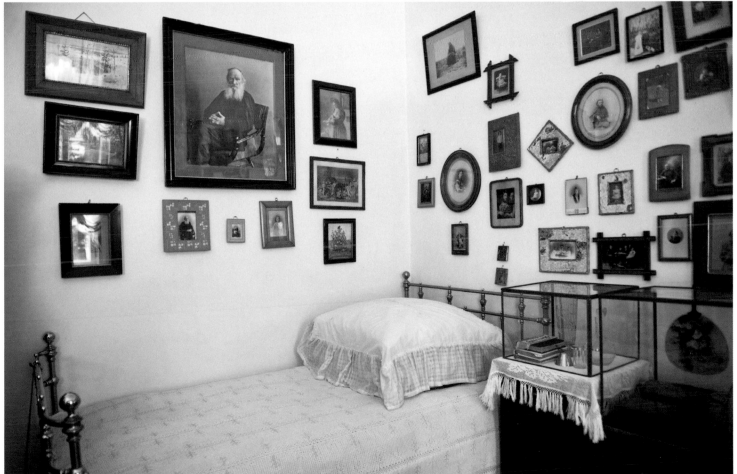

minor appointment in Moscow's military bureaucracy. The magic solution for Tolstoy's father, as for Nikolay Rostov, was a rich bride. In the novel she appears as Princess Maria Bolkonskaya; in real life she was Princess Maria Volkonskaya (1790–1830). It was through Maria Volkonskaya that Nikolay Ilyich's family came to be connected with Yasnaya Polyana, the country estate that would be irrevocably linked to Tolstoy's name.

Compared to the Volkonskys, who were descended from the legendary Scandinavian settler Ryurik, the ninth-century founder of Russia, the Tolstoys were actually mere parvenus as a noble family. Tolstoy's maternal ancestors came from some of the most eminent families in Russia. As a Tolstoy, Nikolay Ilyich was a count, but *Graf* was a title imported from Germany by Peter the Great only in the eighteenth century, along with that of *Baron*, as part of his Europeanization programme. The Russian tradition of each child inheriting the family title, rather than just the eldest son, meant that there were soon hundreds of counts and barons mingling with the old-world Russian princes and princesses.

Tolstoy's maternal great-grandfather, Major General Sergey Volkonsky, had bought a share of the Yasnaya Polyana property when he retired from the army in 1763, and he later bought out the other part-owners. His son, Tolstoy's grandfather Nikolay Sergeyevich Volkonsky (1753–1821), inherited the Yasnaya Polyana estate in 1784. He was a widower when he brought his nine-year-old daughter Maria to live there after retiring, and he never remarried. For the remaining two decades of his life he devoted himself to Maria's upbringing, and to creating the idyllic surroundings that would later become instrumental to his grandson's creativity. It was Nikolay Volkonsky who transformed Yasnaya Polyana from a fairly ordinary piece of land into a carefully landscaped estate, complete with ponds, gardens, paths and

imposing manor house, when he retired from the army in 1799.

Yasnaya Polyana would be Maria Volkonskaya's home for the rest of her life. At the age of thirty-two, she probably thought she would never marry, but she was then introduced by relatives to Nikolay Tolstoy, who was four years her junior and a distant relative (her great-grandmother Praskovya was also his great-aunt). They married in June 1822. By the time Lev Nikolayevich Tolstoy was born, in 1828, Yasnaya Polyana was quite crowded. Nikolay Tolstoy had brought various members of his family to live at the estate after marrying Maria Volkonskaya. Apart from his venerable mother, Pelageya Nikolayevna, there was his younger sister Alexandra Ilyinichna and his distant 'aunt' Tatyana Alexandrovna Ergolskaya, whose father had been Tolstoy's grandmother's cousin. Lev Tolstoy's arrival followed that of his elder brothers Nikolay, Sergey and Dmitry, who were born in 1823, 1826 and 1827. Maria Nikolayevna died in 1830, not long after the birth of her only daughter, also christened Maria. Nikolay Ilyich was by all accounts an attentive husband, and he became a conscientious father as a single parent, devoted to his five children, but he himself died seven years later.

During his early childhood, Lev Tolstoy had the opportunity to meet Count Fyodor Ivanovich (1782–1846), his uncle once removed, whom he later described as an 'extraordinary, lawless, and attractive man'. Fyodor Ivanovich was the wildest Tolstoy of them all. He fought his first duel at the age of seventeen, soon after joining the elite Preobrazhensky Guards regiment in St Petersburg. Four years later, he escaped the confines of military life by securing a berth on Adam von Krusenstern's ship *Nadezhda*, as part of the mission to complete the first Russian round-the-world expedition. Without much to do on board ship, Fyodor Ivanovich amused himself by provoking arguments with the crew and

carrying out outrageous pranks. While visiting a Polynesian island in the South Pacific, he decided to emulate the natives by having his body completely covered in tattoos. When the *Nadezhda* arrived at the Kamchatka Peninsula on the eastern edge of the Russian Empire, Captain Krusenstern ordered Tolstoy to leave the ship.

Fyodor Tolstoy's life became so shrouded in legend and prurient gossip that it is difficult to establish the veracity of the many stories that circulated about him, but he did spend time with native tribes on Sitka Island in southern Alaska, then part of the colony called Russian America. This is how he came to acquire his nickname 'Tolstoy the American'. Further swashbuckling exploits ensued when he finally managed to arrive back in St Petersburg.

Fyodor Ivanovich was the living embodiment of what Tolstoy defined as the fundamental family trait of *dikost*, a word that can mean 'wildness' but also 'shyness' or 'eccentricity'. When applying this word to members of his family, Tolstoy liked further to define *dikost* as the quality of possessing passion, daring, originality and independence of thought, as well as a propensity for doing the opposite of everyone else. Tolstoy himself certainly went against the grain in almost everything he did as an adult, and perceived *dikost* not only in many of his ancestors, but also in some of his contemporaries – even his very prim and proper first cousin once removed, who was a spirited but nevertheless very poised lady-in-waiting at the imperial court. 'You've got the Tolstoyan *dikost* that we all have', he wrote to Alexandra Andreyevna in 1865. 'It was not for nothing that Fyodor Ivanovich got himself tattooed.' In keeping with Tolstoyan *dikost*, Fyodor Ivanovich continued to be full of surprises after finally retiring to Moscow post-1812. He gave up fighting duels and gambling, calmed down and married a gypsy singer.

Besides Lev Nikolayevich and Fyodor Ivanovich, the senior titled branch of the Tolstoy family in the nineteenth century could boast the poet Alexey Konstantinovich Tolstoy and the artist Fyodor Petrovich Tolstoy. The 'middle' titled branch of the family, meanwhile, also had the Tolstoyan creative gene. Count Alexey Nikolayevich, born in 1882, became a celebrated writer, as did his granddaughter Tatyana, born in 1951. With so many different branches, this august family is in no danger of dying out. Lev Tolstoy's children Sergey, Tatyana, Ilya, Lev, Andrey and Mikhail alone produced thirty-two grandchildren, who in turn produced fifty-six great-grandchildren. The writer's great-great grandson Vladimir Ilych (see p. 58), born in 1962, became Director of the Yasnaya Polyana Museum-Estate in 1994 (his wife, Ekaterina, took over the role in 2012; see p. 138), and was responsible for making the regular Tolstoy reunions at the ancestral home an institution. He is unabashed about his feelings of deep attachment to his family:

I would like to confess openly about being biased: I love the Tolstoys. All of them. Those living, those who passed away long ago, close relatives, distant relatives, Lev Nikolayevich's descendants, representatives of other branches of the family, those who have kept the ancestral name through male descent, and those who have exchanged it through female descent for all kinds of other surnames from round the world. I also find it interesting being with them, I know hardly any stodgy, boring or stupid people among them. We may have a different attitude towards life, we may argue and not understand each other, we may fall out or even avoid being in contact, but I am always drawn back towards my own kin, and feel in them the same 'Tolstoyan dikost*', the same temperament, sincerity and passion that I have. Despite everything, we remain one single, big family. And precisely in this lies our greatest strength.*

Overleaf:
Family portraits in Sofya Andreyevna's bedroom.

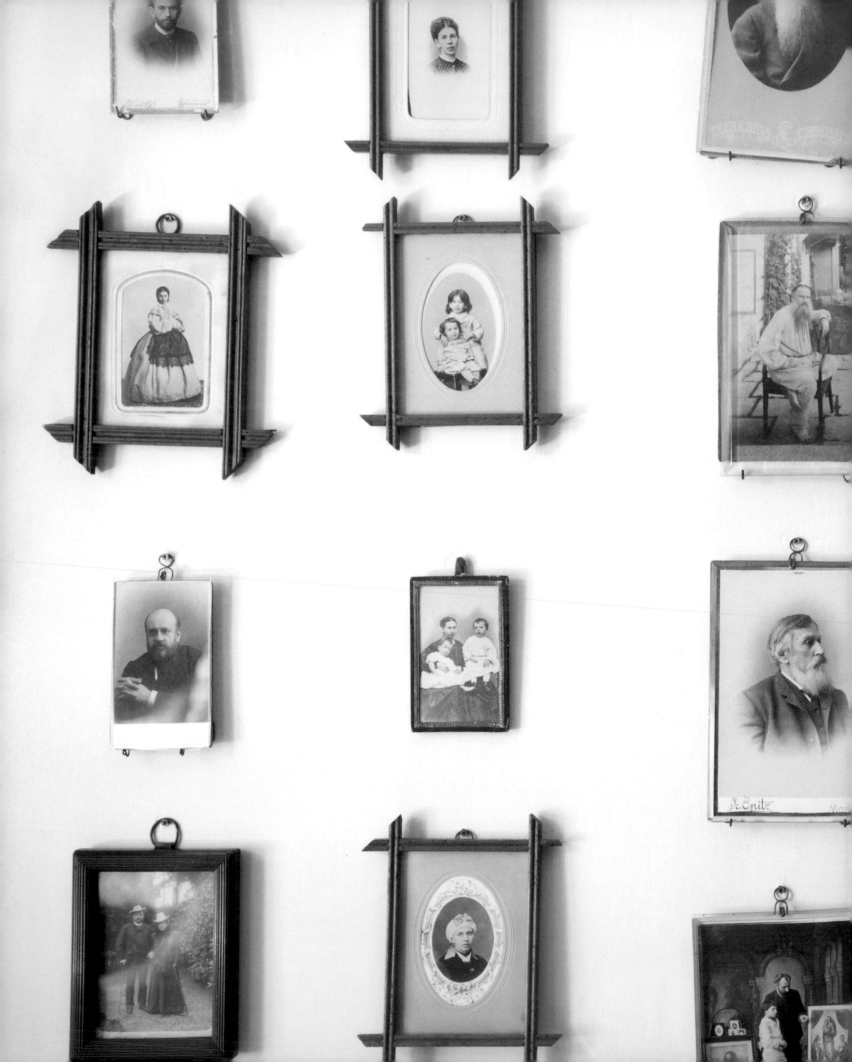

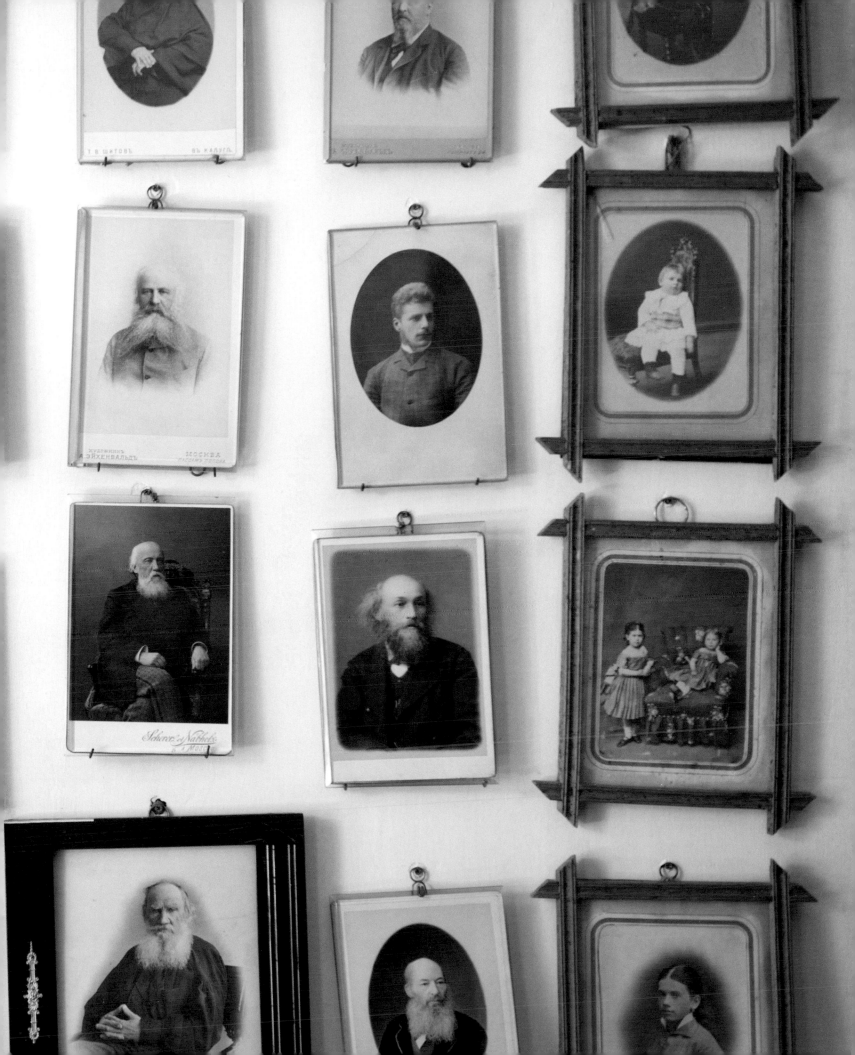

NOTE ON THE PORTRAITS
The portraits appear in the following order: descendants
of Lev Nikolayevich Tolstoy (pp. 28–123); relatives of Lev
Nikolayevich Tolstoy (pp. 124–25); spouses and other relatives
of the descendants of Lev Nikolayevich Tolstoy (pp. 126–65);
other branches of the Tolstoy family (pp. 166–91).

Andrea Albertini
Great-great-grandson
Born 1960

Descendant of Lev Nikolayevich Tolstoy's eldest daughter,
Tatyana Lvovna

Lives in Italy
Senior relationship manager in banking
REF. 104*

* Captions for the descendants of Lev Nikolayevich Tolstoy
include a reference number that relates to the family tree on
'The Tolstoys' website: http://tolstoys.ru/en/tree/descendants

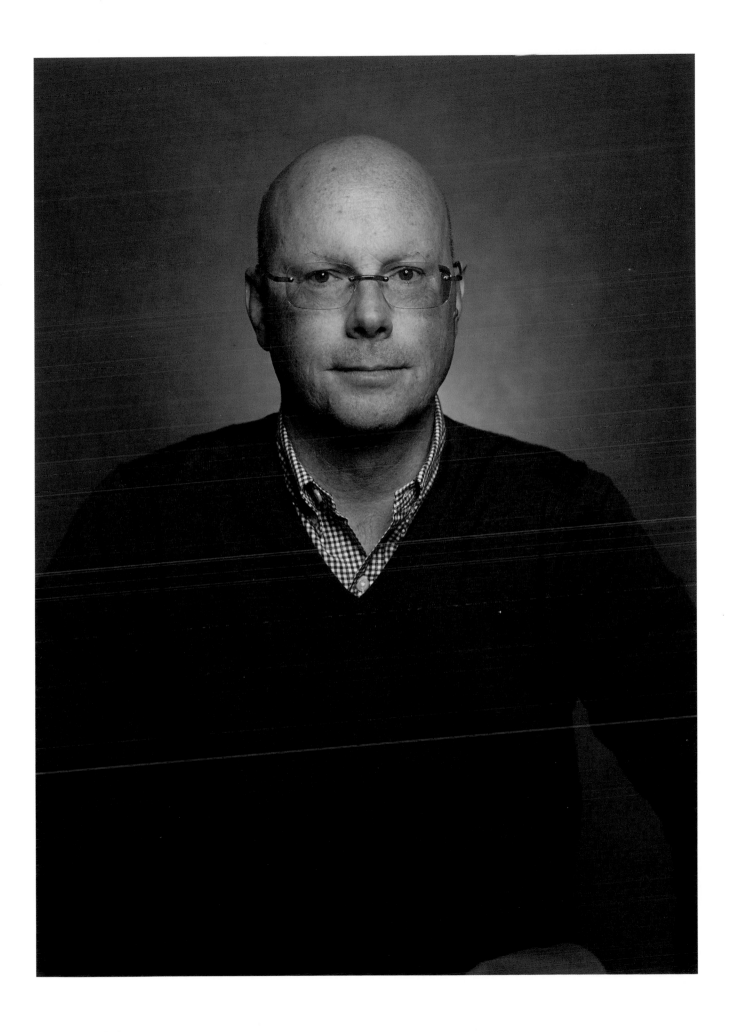

Chiara Andrea Albertini
Great-great-great-granddaughter
Born 1990

Descendant of Lev Nikolayevich Tolstoy's eldest daughter,
Tatyana Lvovna

Lives in Italy
Student
REF. 221

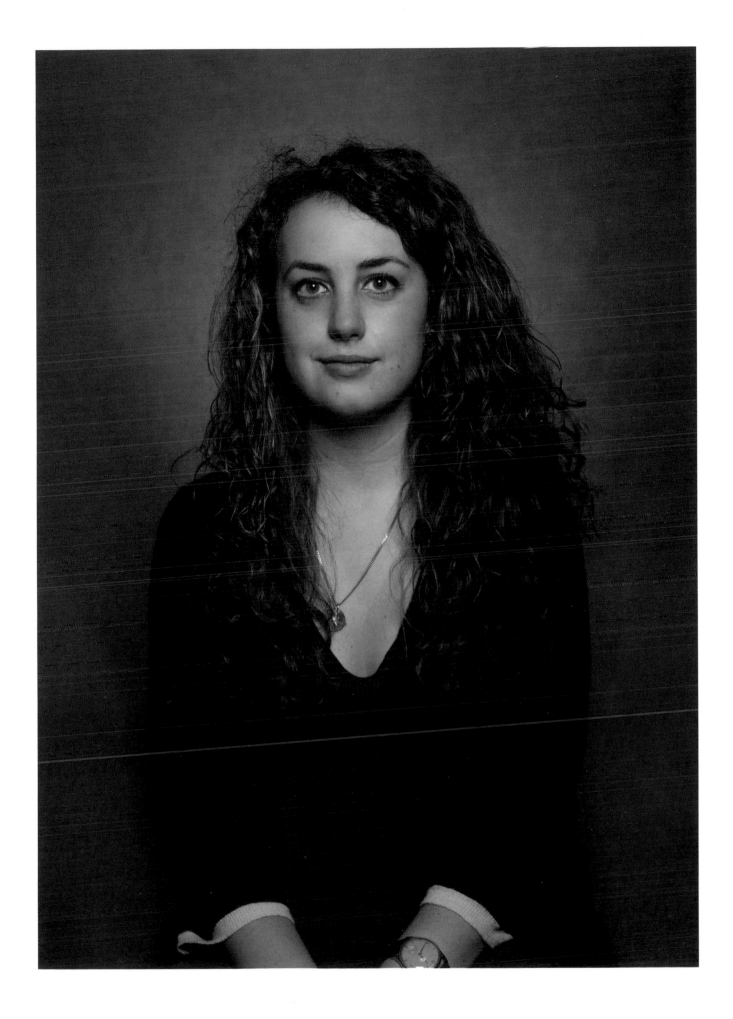

Christina Leonardovna Albertini
Great-granddaughter
Born 1948

Descendant of Lev Nikolayevich Tolstoy's eldest daughter,
Tatyana Lvovna

Lives in Italy
Businesswoman
REF. 50

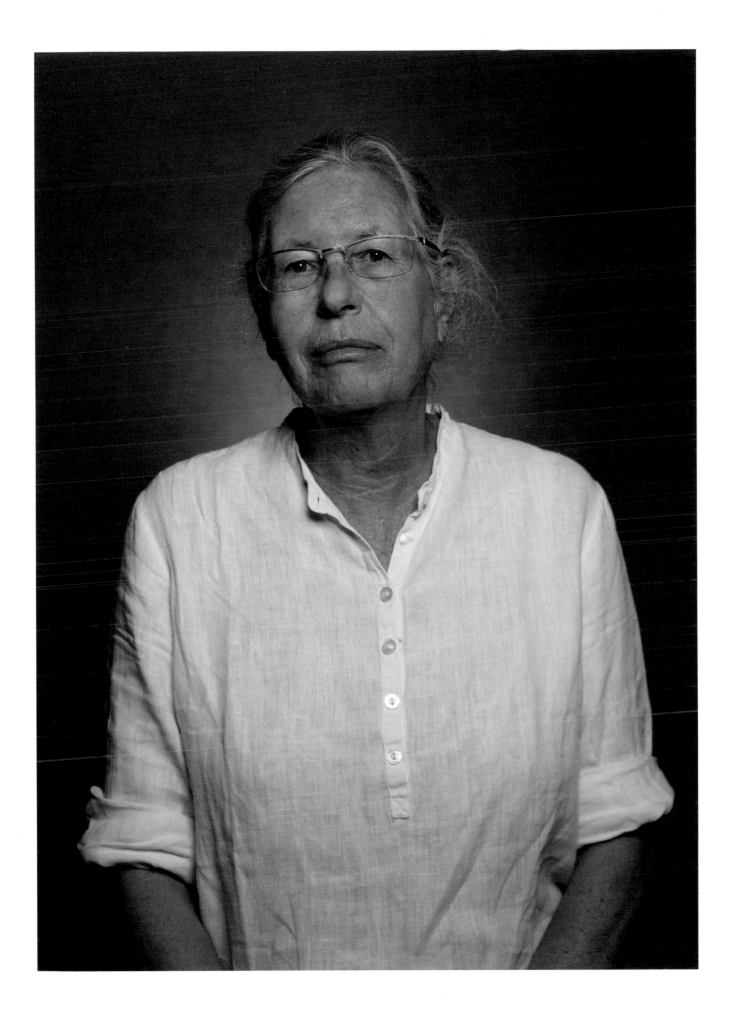

Alessandra Albertini Purificato
Great-great-granddaughter
Born 1981

Descendant of Lev Nikolayevich Tolstoy's eldest daughter,
Tatyana Lvovna

Lives in Italy
Businesswoman
REF. 110

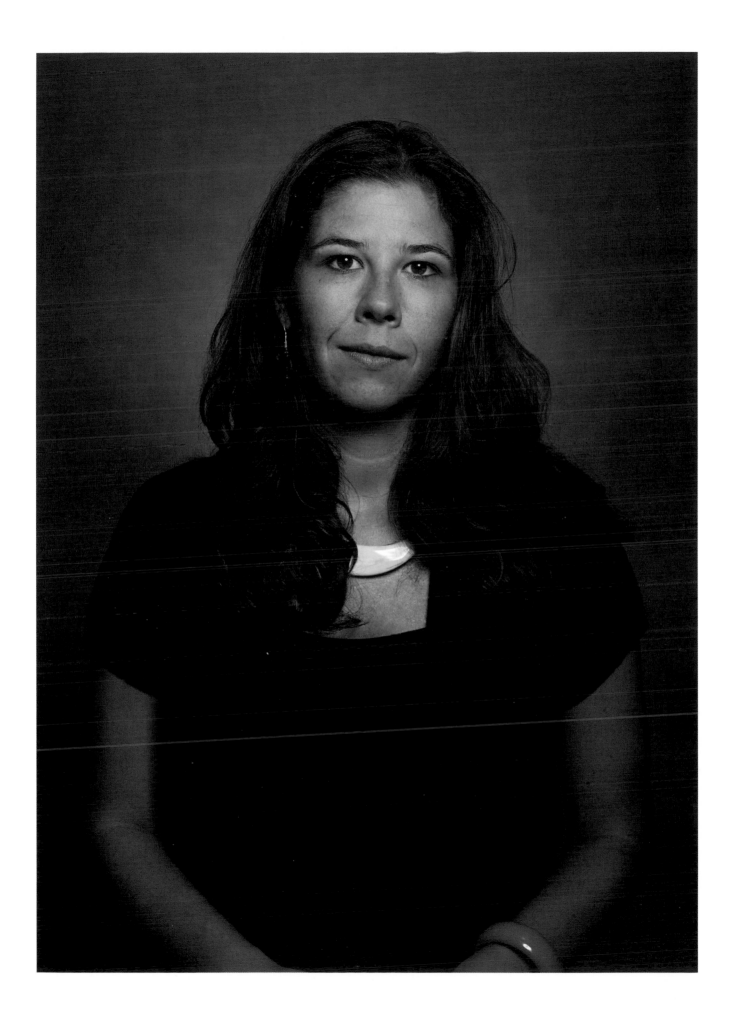

Marfa Nikitichna Tolstaya
Great-great-granddaughter
Born 1965

Descendant of Lev Nikolayevich Tolstoy's third born,
Ilya Lvovich

Lives in Russia
Slavic philologist
REF. III

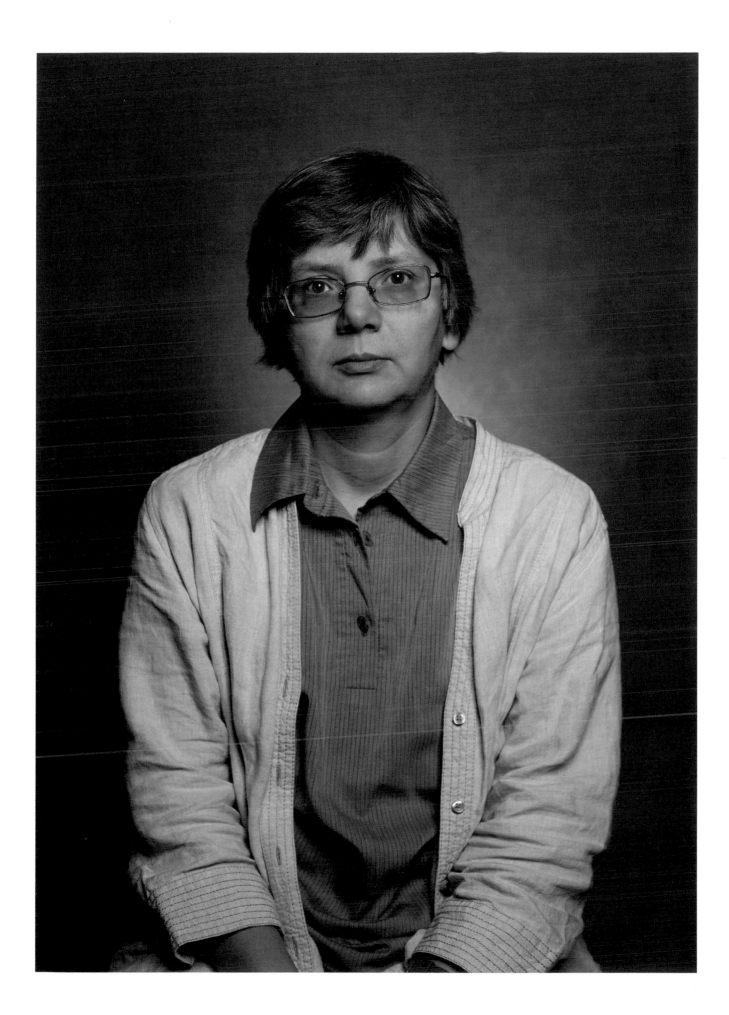

Anna (Fiokla) Nikitichna Tolstaya
Great-great-granddaughter
Born 1971

Descendant of Lev Nikolayevich Tolstoy's third born,
Ilya Lvovich

Lives in Russia
TV broadcaster and presenter
REF. 112

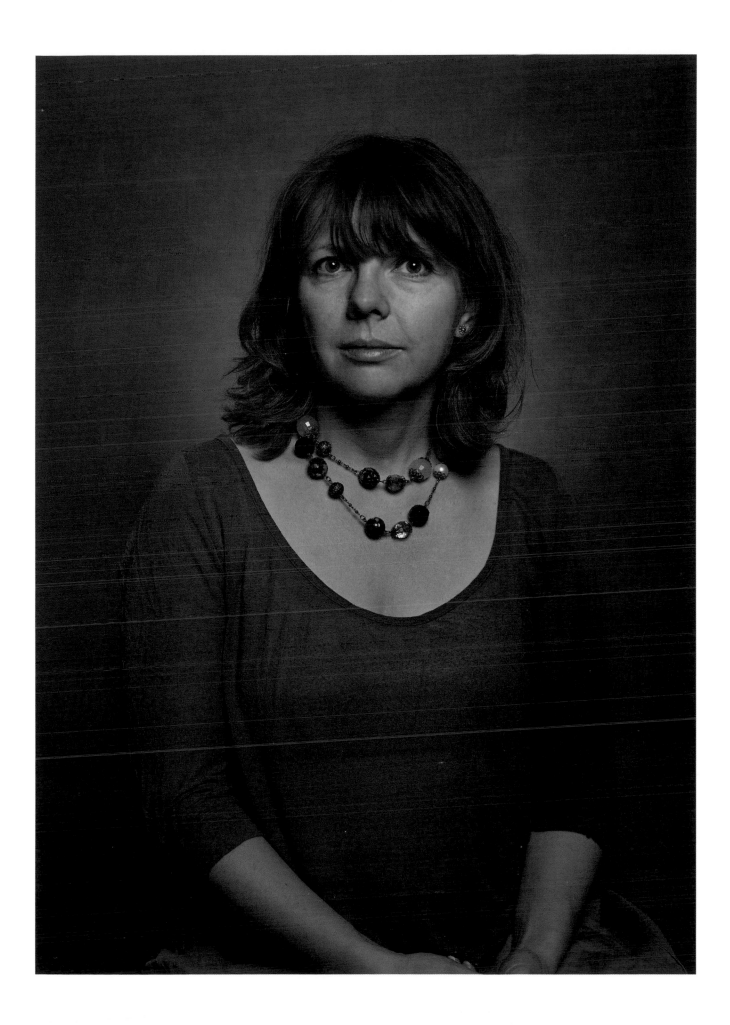

Natalia Olegovna Tolstaya
Great-great-granddaughter
Born 1954

Descendant of Lev Nikolayevich Tolstoy's third born,
Ilya Lvovich

Lives in Russia
Artist
REF. 113

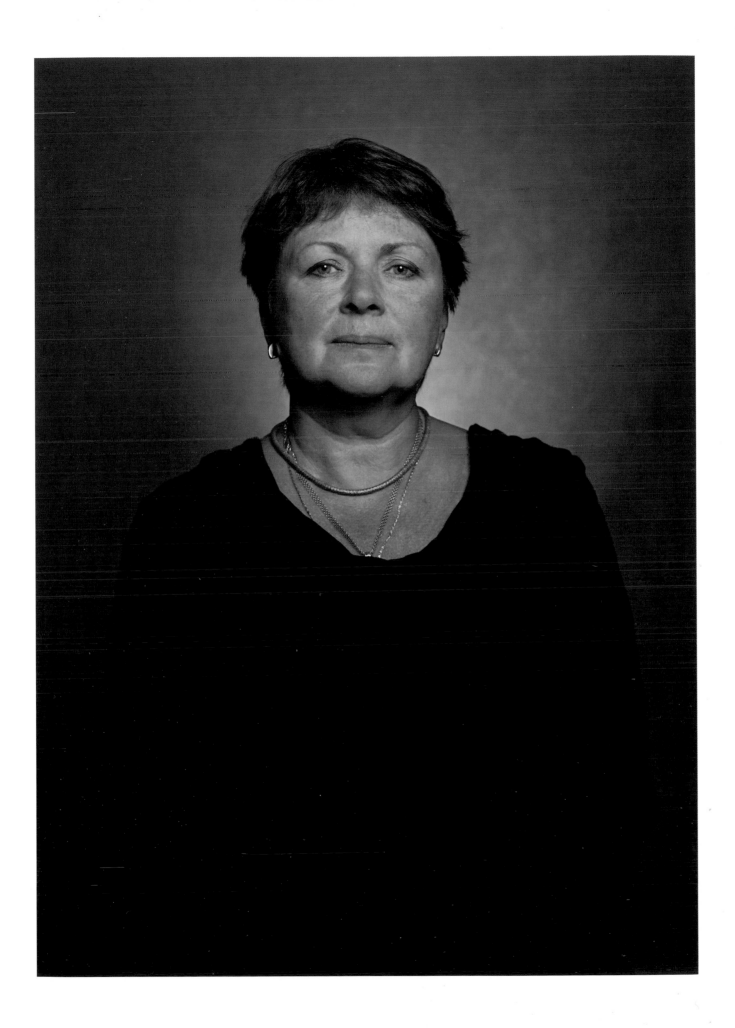

Ivan Vladimirovich Lysiakov
Great-great-great-grandson
Born 1977

Descendant of Lev Nikolayevich Tolstoy's third born,
Ilya Lvovich

Lives in Russia
Head of the Department of Information Resources,
State Museum of Lev Tolstoy
REF. 228

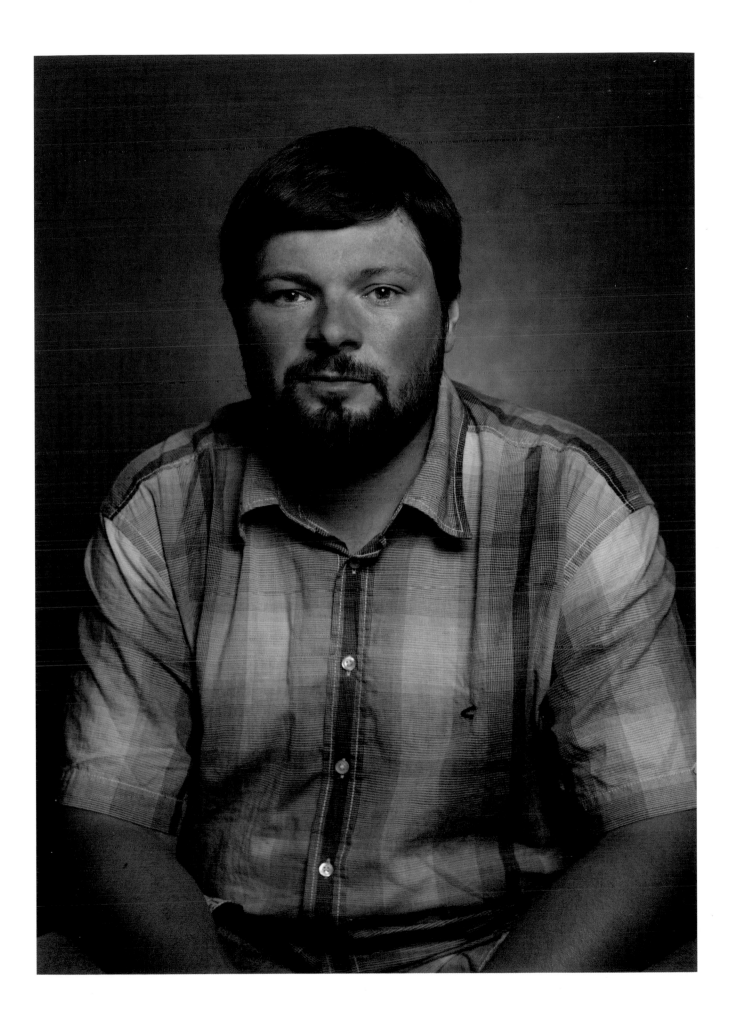

Oleg Ivanovich Lysiakov
Great-great-great-great-grandson
Born 2010

Descendant of Lev Nikolayevich Tolstoy's third born,
Ilya Lvovich

Lives in Russia
REF. 370

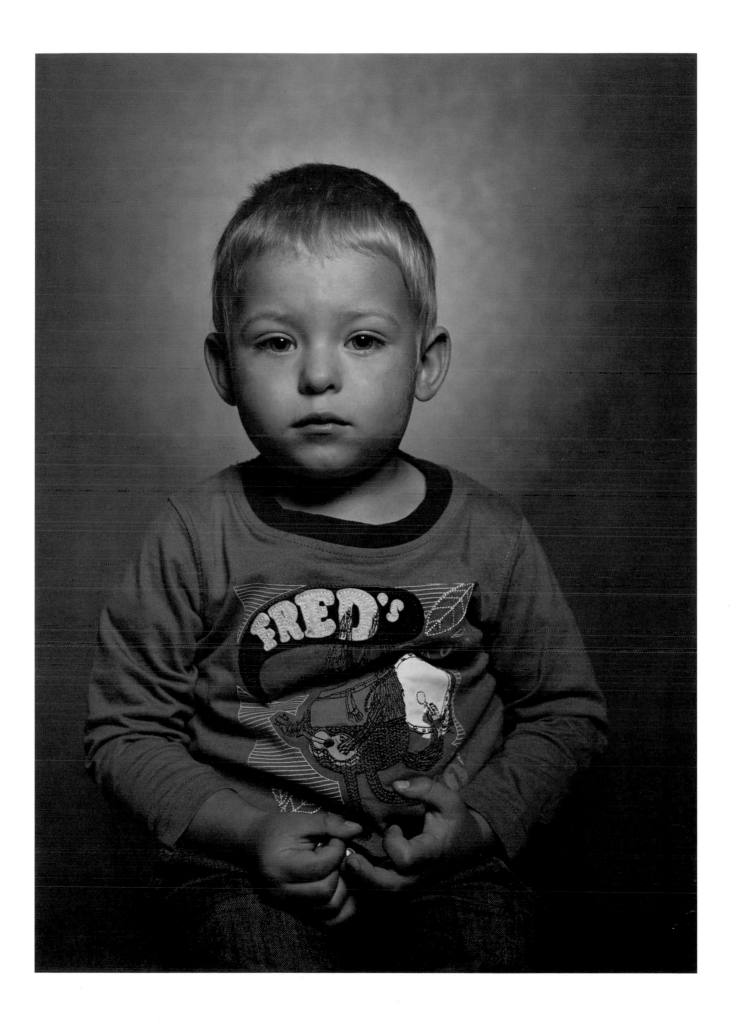

Petr Olegovich Tolstoy
Great-great-grandson
Born 1969

Descendant of Lev Nikolayevich Tolstoy's third born,
Ilya Lvovich

Lives in Russia
TV broadcaster and presenter
REF. 114

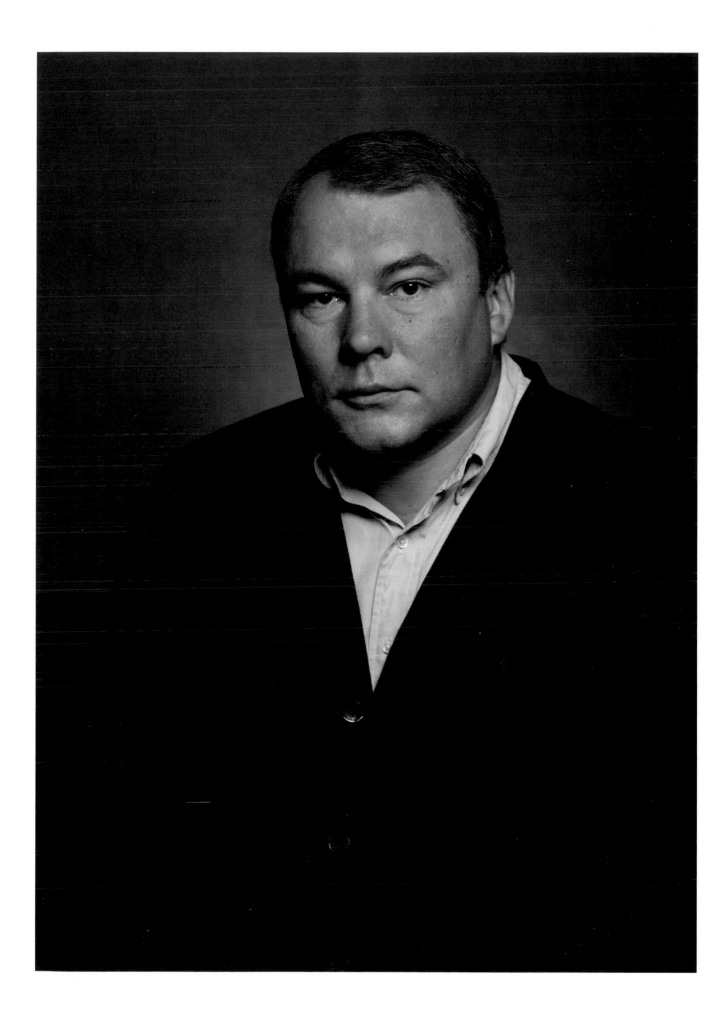

Aleksandra Petrovna Tolstaya
Great-great-great-granddaughter
Born 2000

Descendant of Lev Nikolayevich Tolstoy's third born,
Ilya Lvovich

Lives in Russia
REF. 229

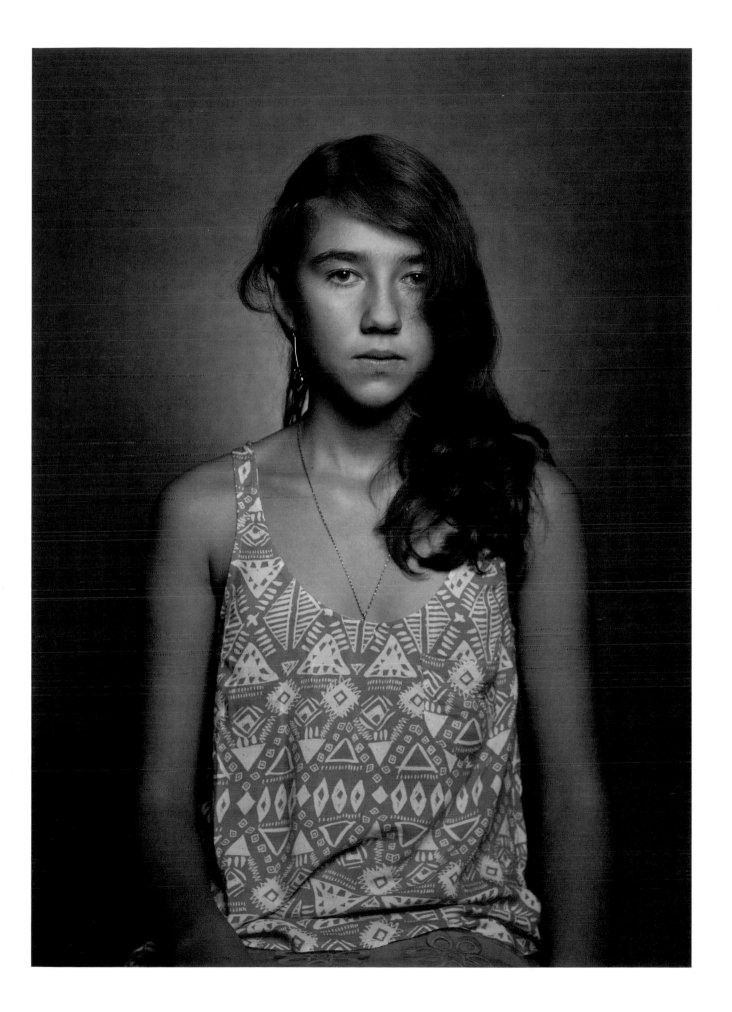

Ilya Ilych Tolstoy
Great-great-grandson
Born 1954

Descendant of Lev Nikolayevich Tolstoy's third born,
Ilya Lvovich

Lives in Russia
Journalist
REF. 115

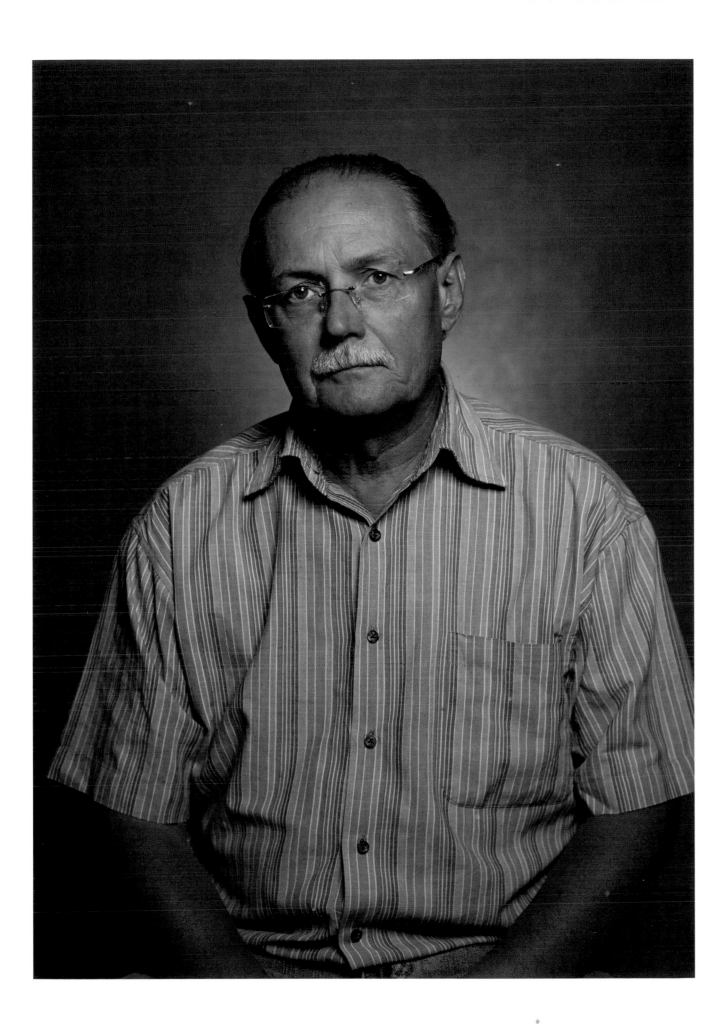

Anna Ilyinichna Tolstaya
Great-great-great-granddaughter
Born 1986

Descendant of Lev Nikolayevich Tolstoy's third born,
Ilya Lvovich

Lives in Russia
TV producer
REF. 230

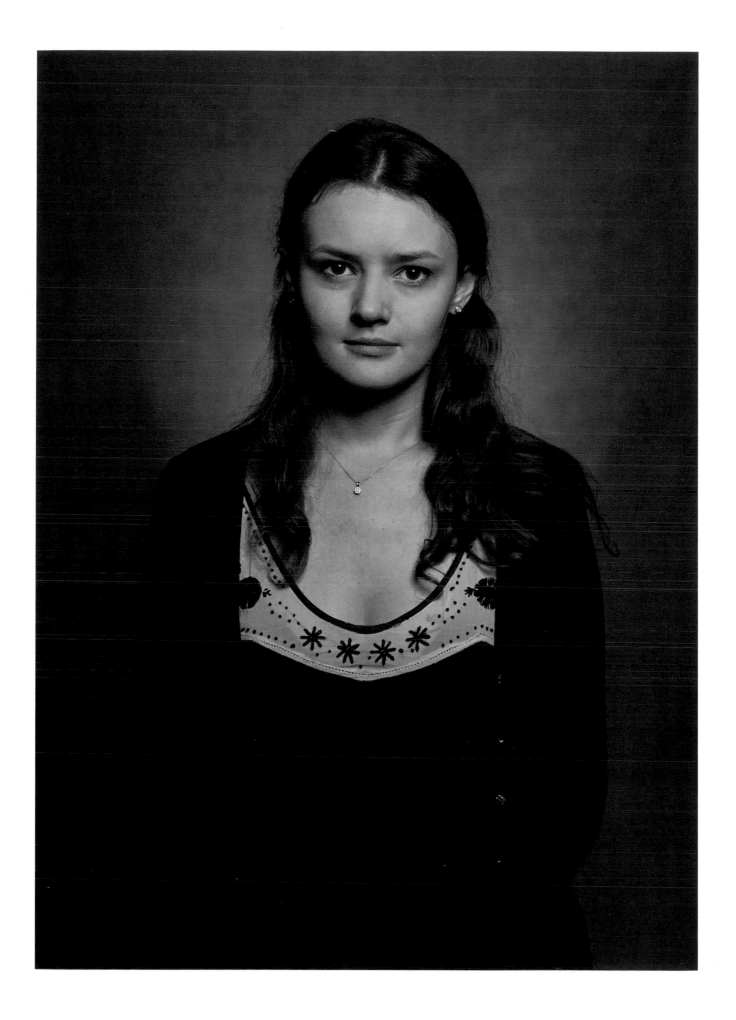

Nikolai Grigorevich Karkishko
Great-great-great-great-grandson
Born 2004

Descendant of Lev Nikolayevich Tolstoy's third born,
Ilya Lvovich

Lives in Russia
REF. 371

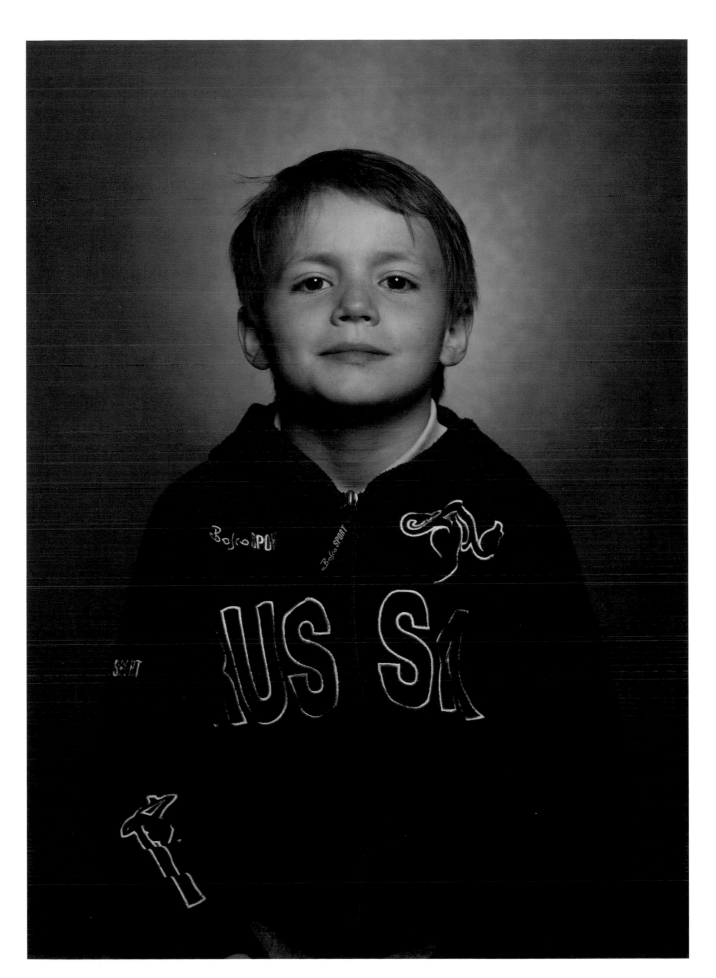

Ilya Ilych Tolstoy
Great-great-great-grandson
Born 1987

Descendant of Lev Nikolayevich Tolstoy's third born,
Ilya Lvovich

Lives in Russia
Photographer
REF. 231

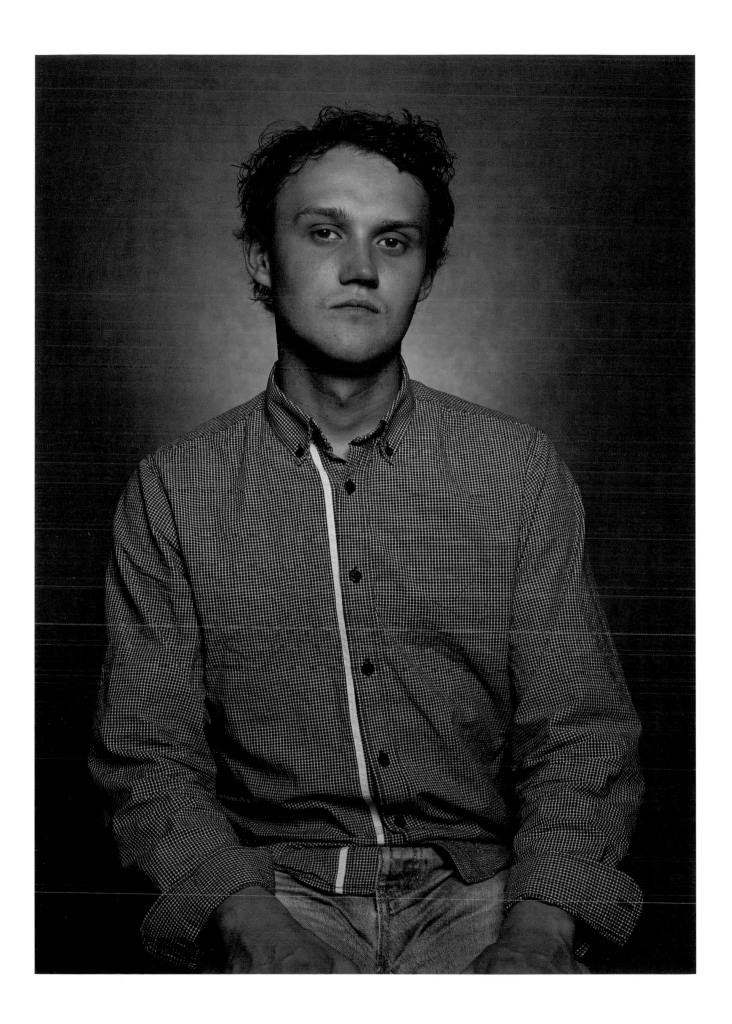

Vladimir Ilych Tolstoy
Great-great-grandson
Born 1962

Descendant of Lev Nikolayevich Tolstoy's third born,
Ilya Lvovich

Lives in Russia
Special Adviser on Cultural Affairs to President Putin
REF. 116

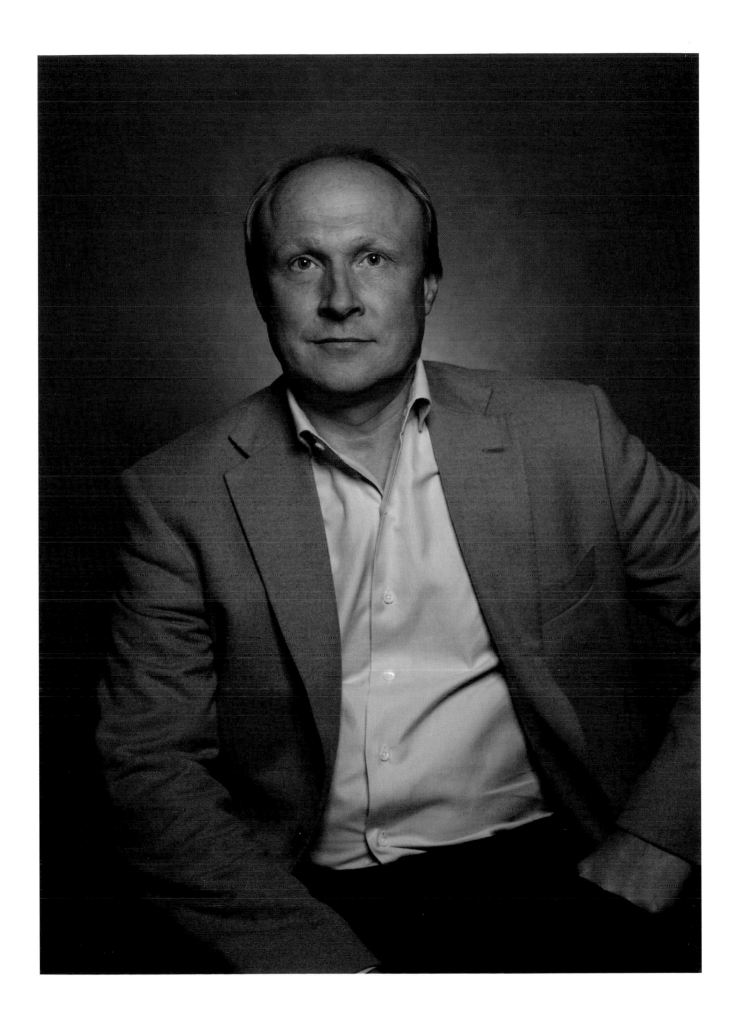

Anastasia Vladimirovna Tolstaya
Great-great-great-granddaughter
Born 1984

Descendant of Lev Nikolayevich Tolstoy's third born,
Ilya Lvovich

Lives in England
Junior Research Fellow, Wolfson College, University of Oxford
REF. 232

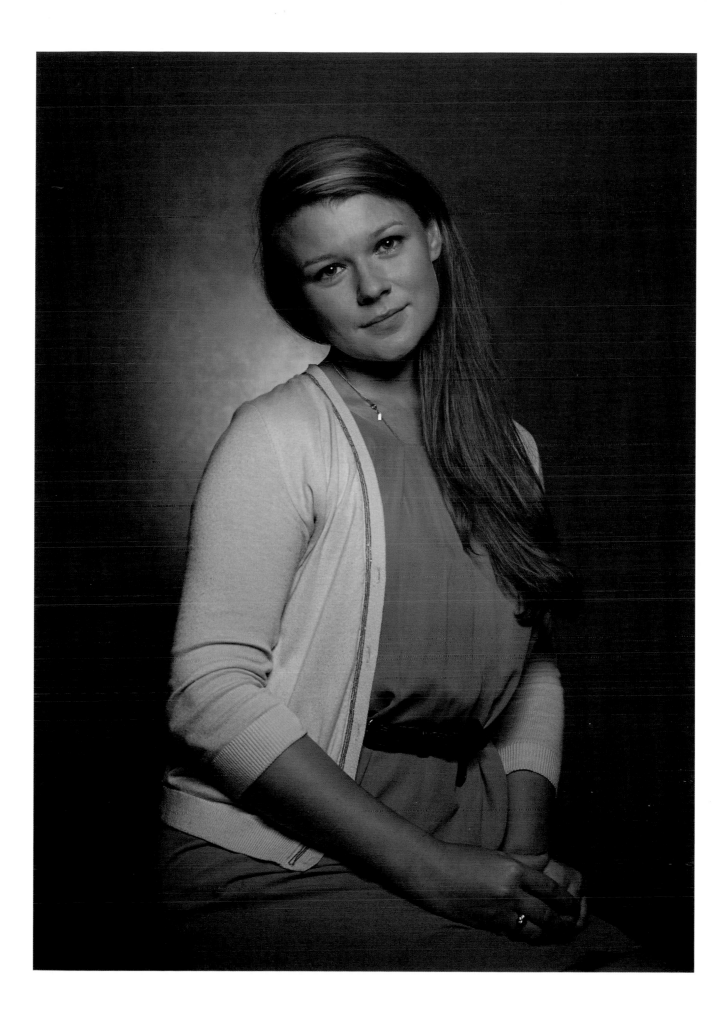

Ekaterina Vladimirovna Tolstaya
Great-great-great-granddaughter
Born 1987

Descendant of Lev Nikolayevich Tolstoy's third born,
Ilya Lvovich

Lives in England
Art historian
REF. 233

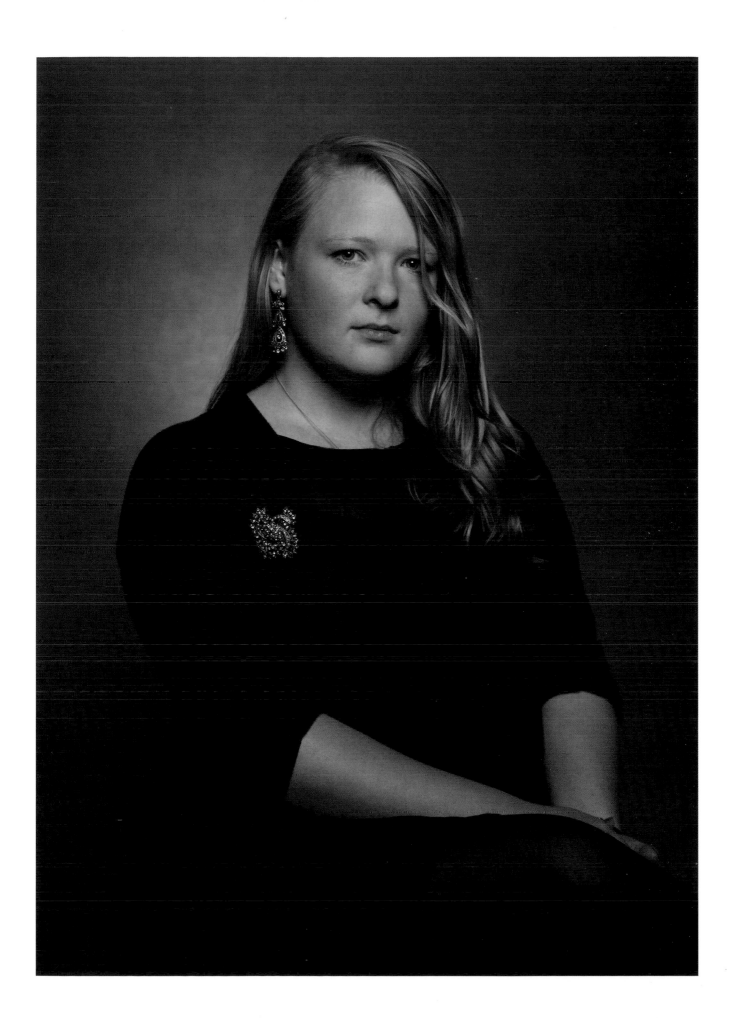

Andrei Vladimirovich Tolstoy
Great-great-great-grandson
Born 1996

Descendant of Lev Nikolayevich Tolstoy's third born,
Ilya Lvovich

Lives in Russia
Student
REF. 234

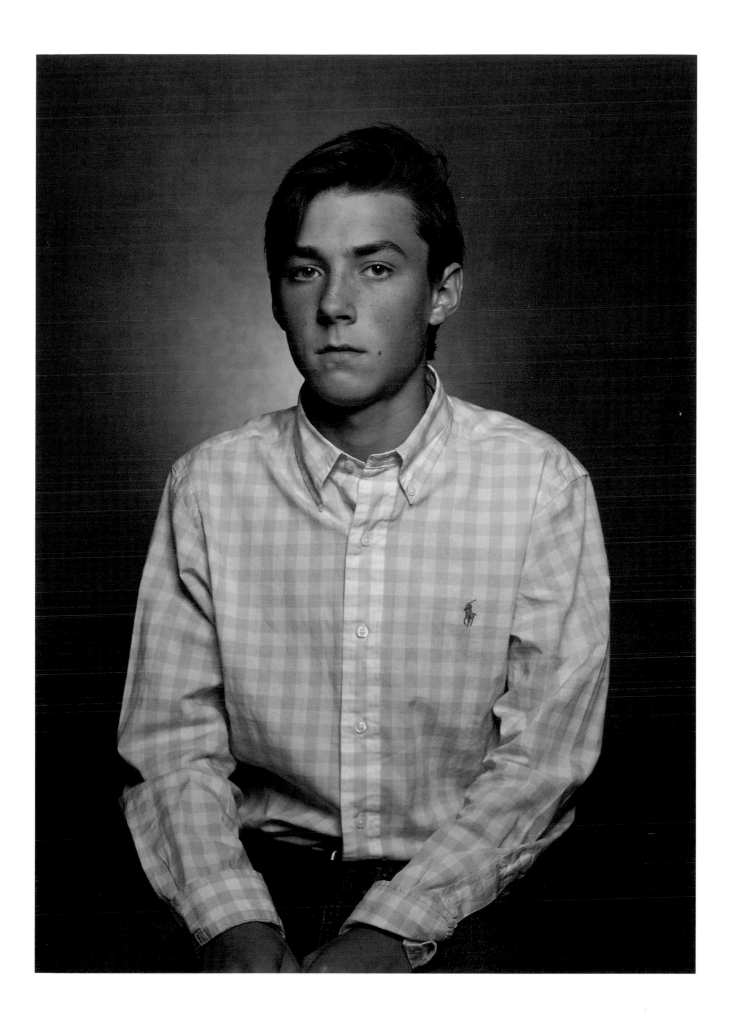

Ivan Vladimirovich Tolstoy
Great-great-great-grandson
Born 1998

Descendant of Lev Nikolayevich Tolstoy's third born,
Ilya Lvovich

Lives in Russia
Student
REF. 235

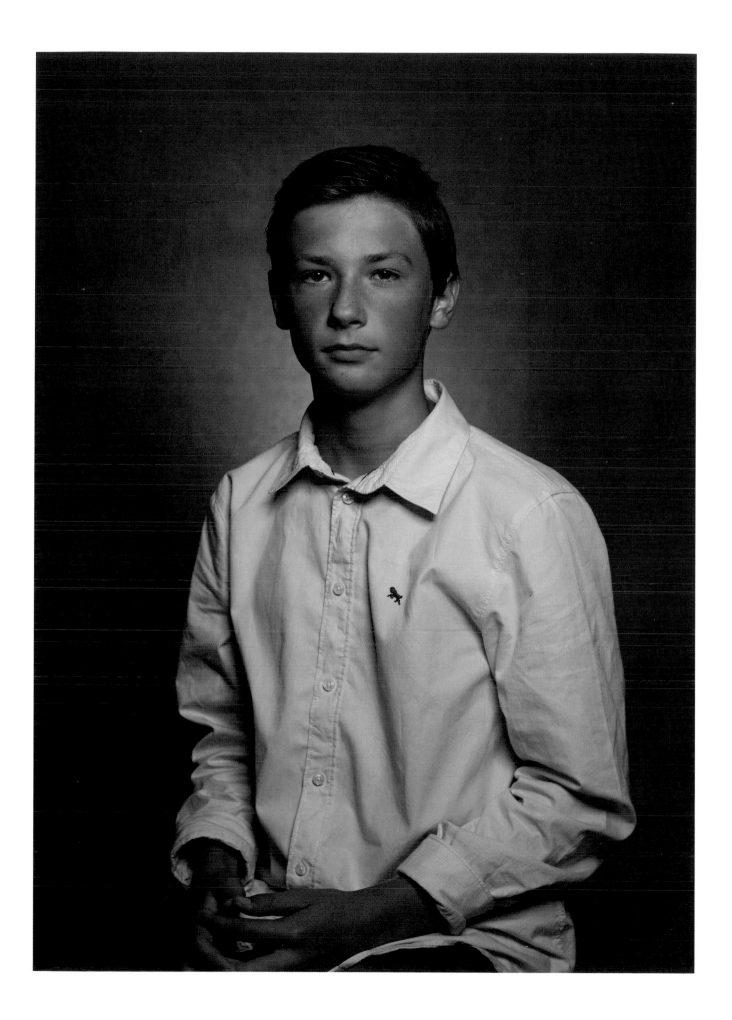

Sophie Stephanovna Tolstoy Regen
Great-great-granddaughter
Born 1967

Descendant of Lev Nikolayevich Tolstoy's fourth born,
Lev Lvovich

Lives in Sweden
Actor
REF. 129

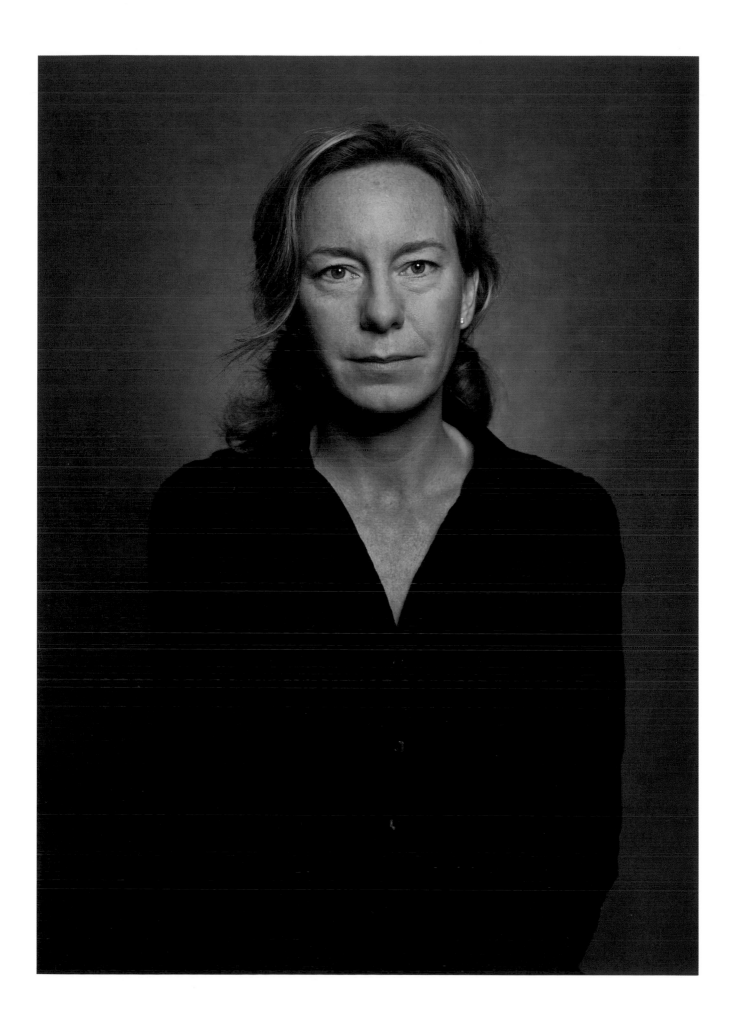

Lou Folke Regen
Great-great-great-granddaughter
Born 1997

Descendant of Lev Nikolayevich Tolstoy's fourth born,
Lev Lvovich

Lives in Sweden
Student
REF. 256

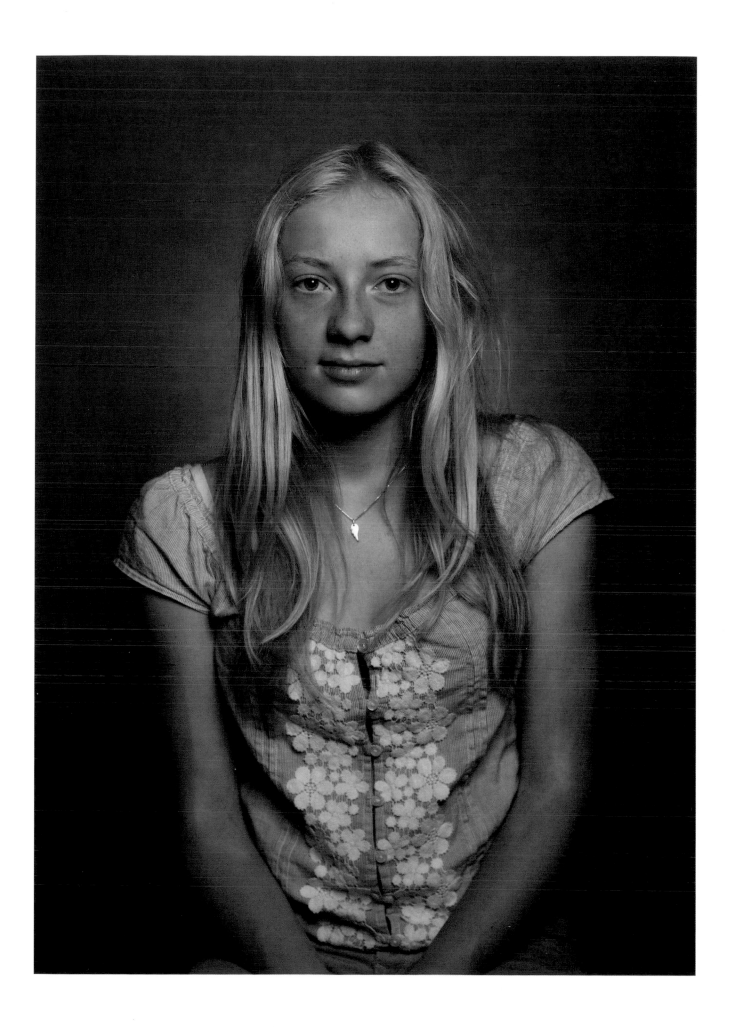

Daniil Nikitich Tolstoy
Great-grandson
Born 1972

Descendant of Lev Nikolayevich Tolstoy's fourth born,
Lev Lvovich

Lives in Sweden
Director of the Raketa watch company
REF. 63

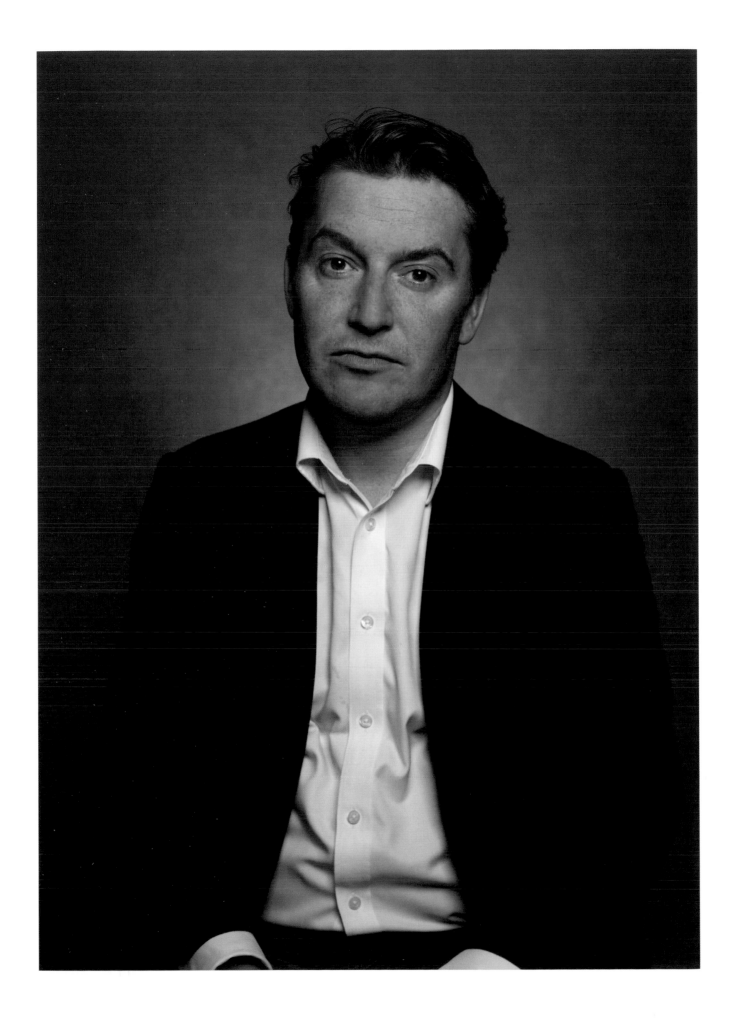

Anastasia Daniilovna Tolstoy
Great-great-granddaughter
Born 2006

Descendant of Lev Nikolayevich Tolstoy's fourth born,
Lev Lvovich

Lives in Sweden
Daughter of Daniil Nikitich Tolstoy (see p. 72) and
Nina (Rutger) Tolstoy (see p. 140)

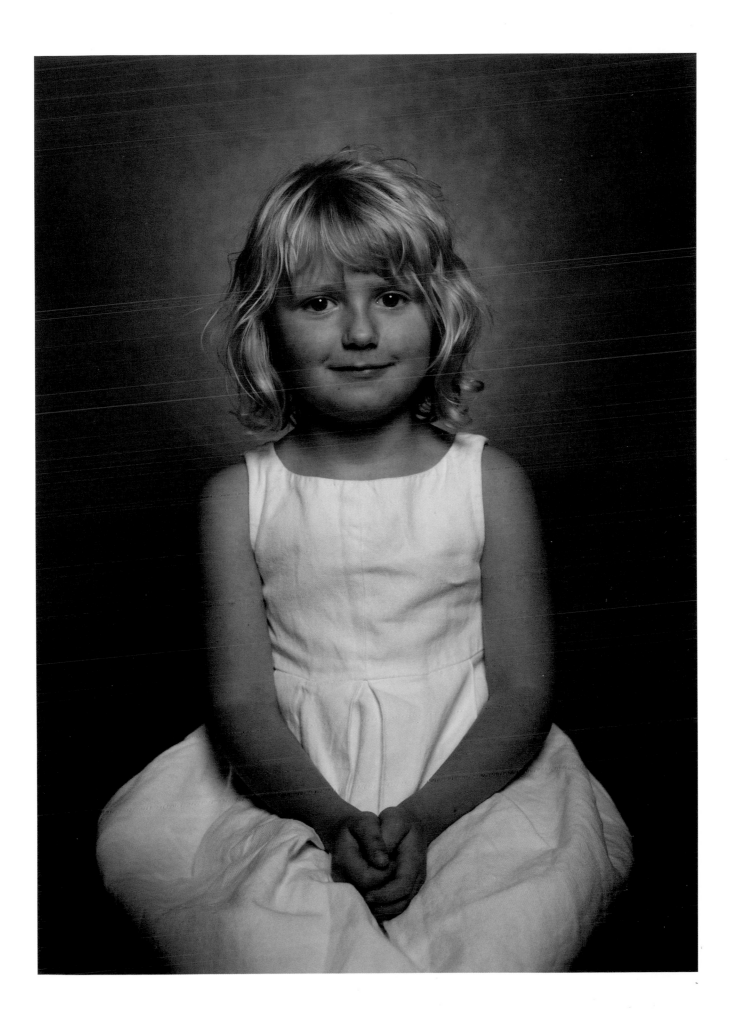

Catarina Lundeberg Hjort
Great-great-granddaughter
Born 1962

Descendant of Lev Nikolayevich Tolstoy's fourth born,
Lev Lvovich

Lives in Sweden
Physical education teacher
REF. 151

Amanda Lundeberg Hjort
Great-great-great-granddaughter
Born 1993

Descendant of Lev Nikolayevich Tolstoy's fourth born,
Lev Lvovich

Lives in Sweden
Student
REF. 304

Signe Bergström
Great-granddaughter
Born 1939

Descendant of Lev Nikolayevich Tolstoy's fourth born,
Lev Lvovich

Lives in Sweden
Retired CEO in occupational health care
REF. 74

Ylva (Bergström) Berling-Pesant
Great-great-granddaughter
Born 1965

Descendant of Lev Nikolayevich Tolstoy's fourth born,
Lev Lvovich

Lives in France
Senior Human Resources Adviser, Organization for
Economic Cooperation and Development
REF. 157

Oscar Berling-Pesant
Great-great-great-grandson
Born 1999

Descendant of Lev Nikolayevich Tolstoy's fourth born,
Lev Lvovich

Lives in France
Student
REF. 311

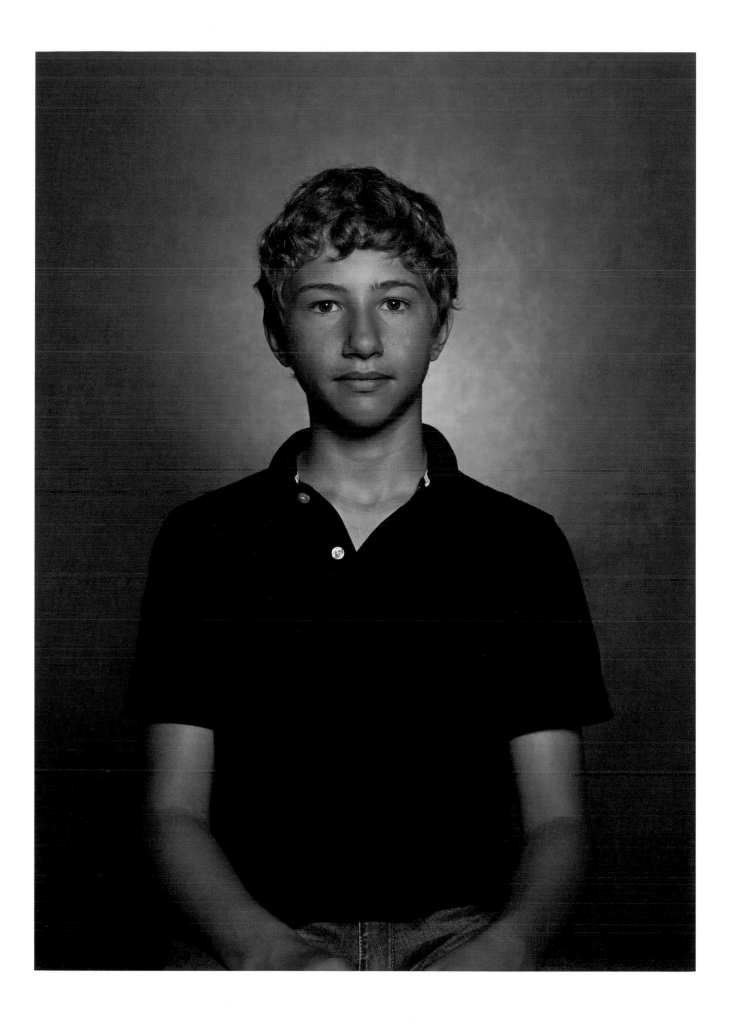

Anne-Charlotte Ceder Bergmark
Great-granddaughter
Born 1944

Descendant of Lev Nikolayevich Tolstoy's fourth born,
Lev Lvovich

Lives in Sweden
Retired director of an occupational health service company
REF. 75

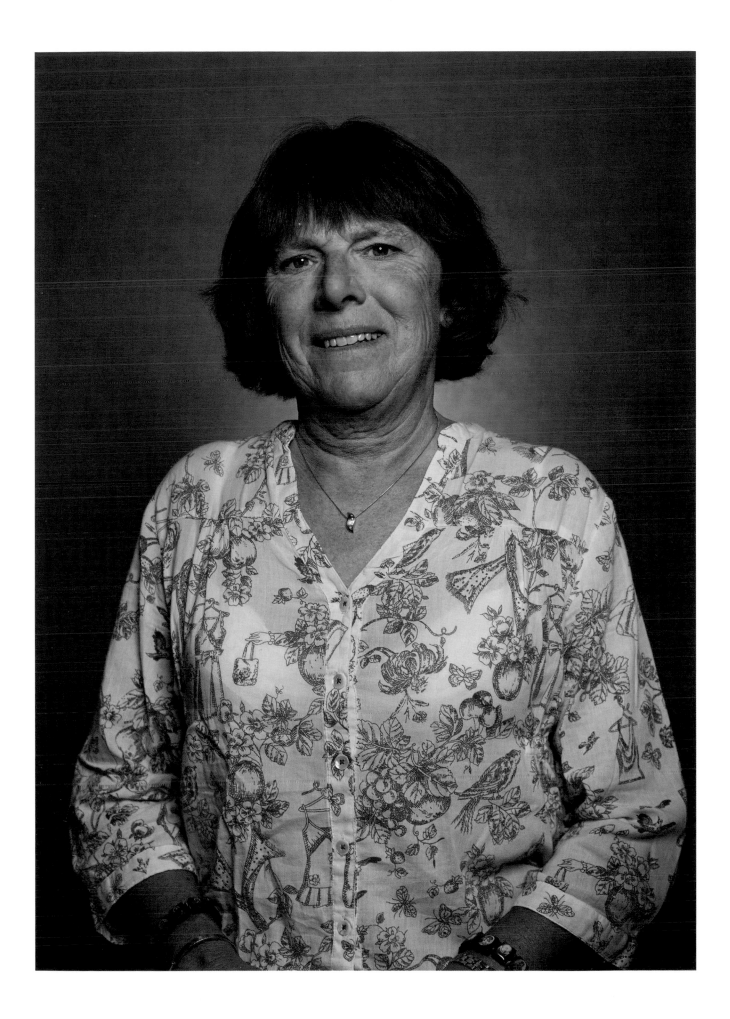

Carl Per Eric Effert Bergmark
Great-great-grandson
Born 1969

Descendant of Lev Nikolayevich Tolstoy's fourth born,
Lev Lvovich

Lives in Sweden
Banker
REF. 159

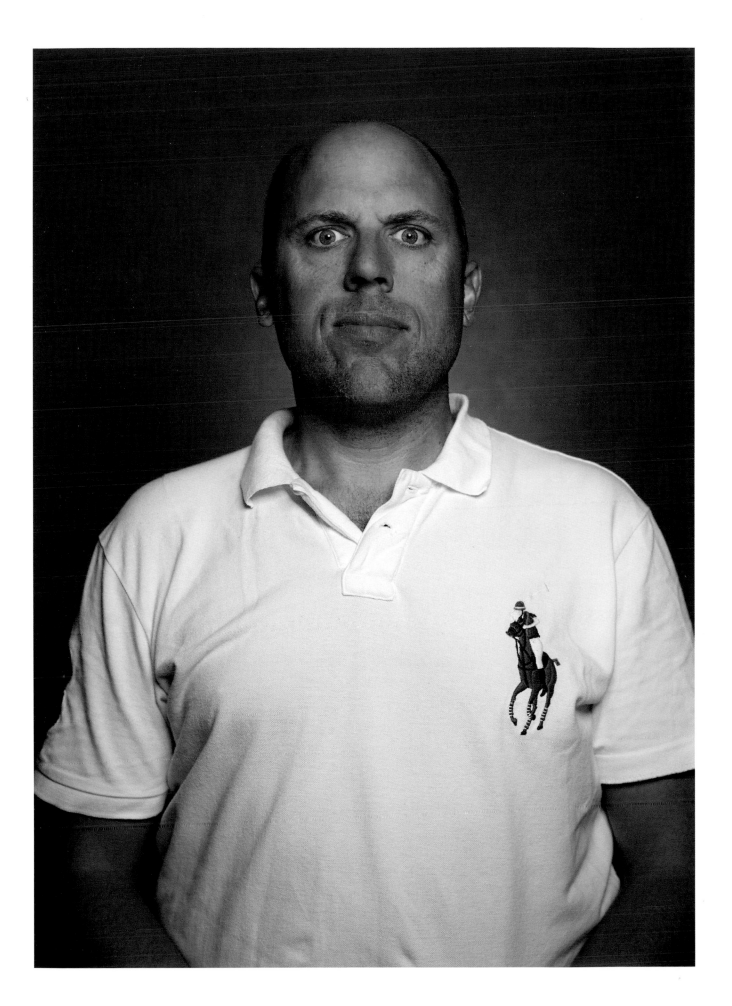

Carl Leo Eric Effert
Great-great-great-grandson
Born 1999

Descendant of Lev Nikolayevich Tolstoy's fourth born,
Lev Lvovich

Lives in Sweden
Student
REF. 314

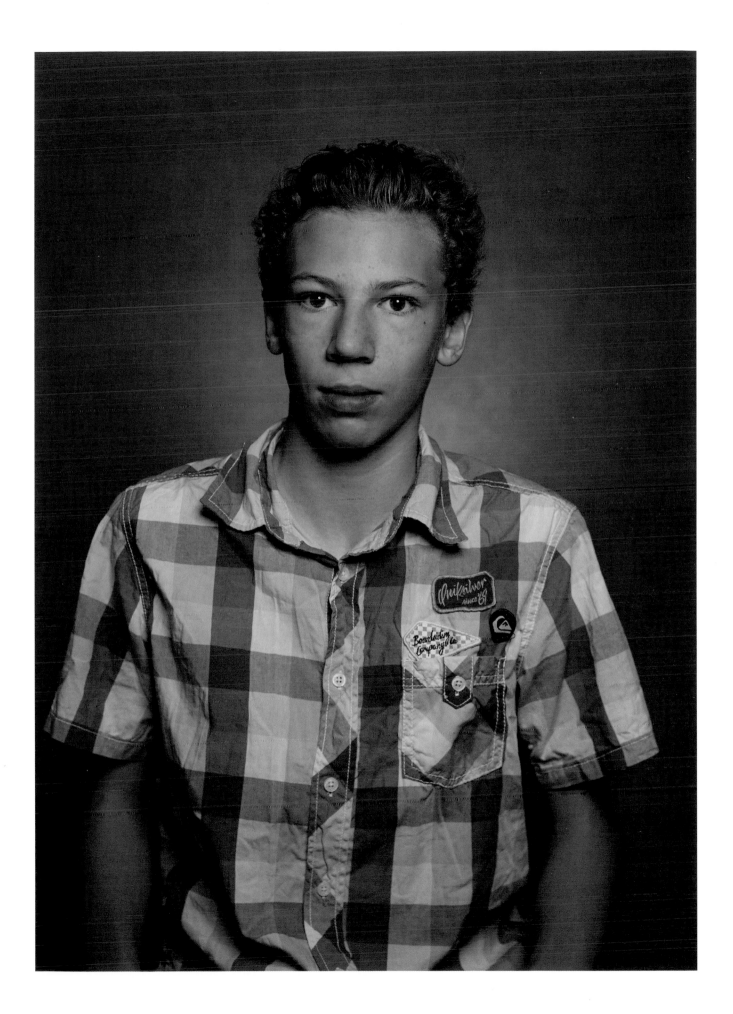

Carl Axel Nikolaj Effert
Great-great-great-grandson
Born 2001

Descendant of Lev Nikolayevich Tolstoy's fourth born,
Lev Lvovich

Lives in Sweden
REF. 315

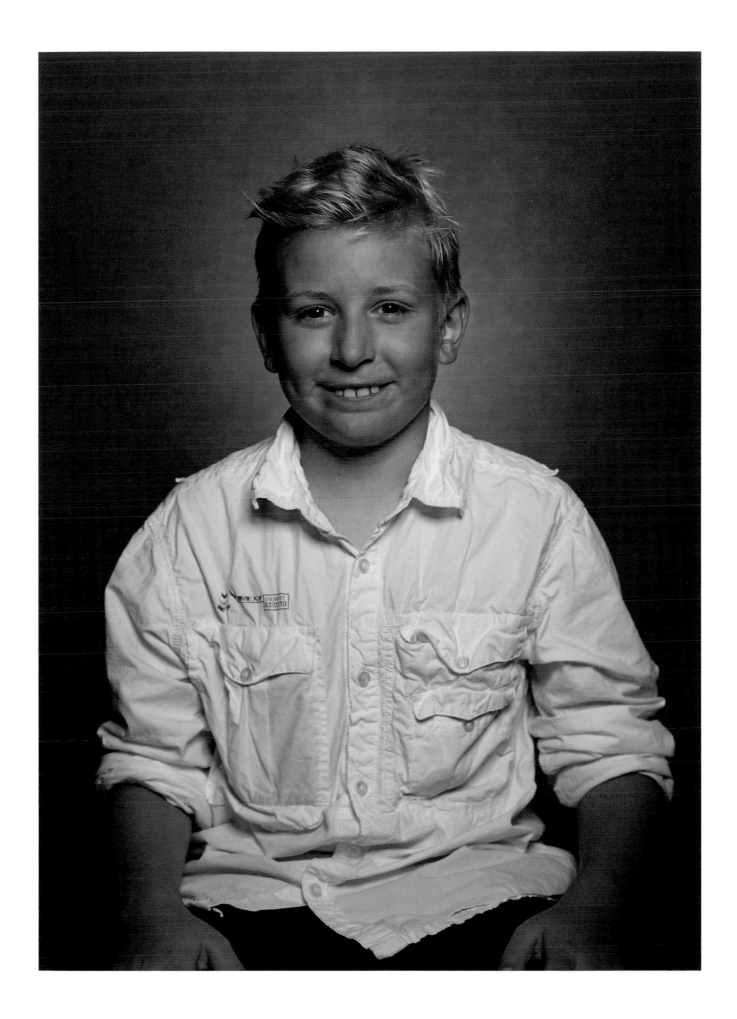

Pyotr Vladimirovich Benetka
Great-great-grandson
Born 1965

Descendant of Lev Nikolayevich Tolstoy's ninth born,
Andrey Lvovich

Lives in Czech Republic
Manager in asset management
REF. 185

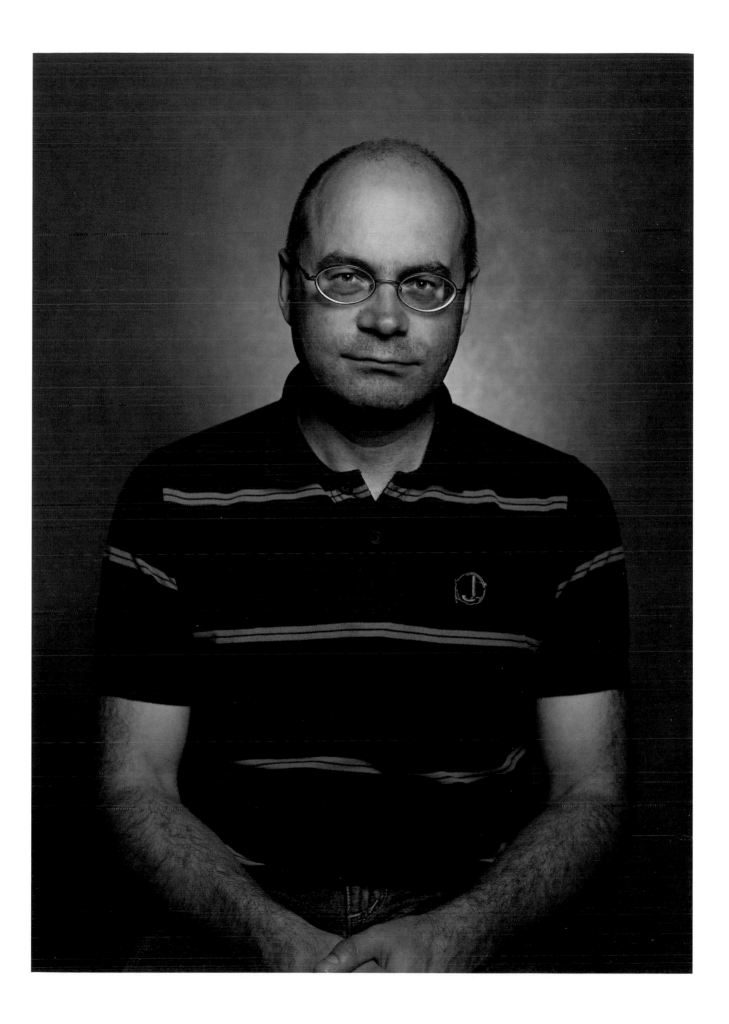

Nela Pyotrovna Benetka
Great-great-great-granddaughter
Born 2006

Descendant of Lev Nikolayevich Tolstoy's ninth born,
Andrey Lvovich

Lives in Czech Republic
REF. 331

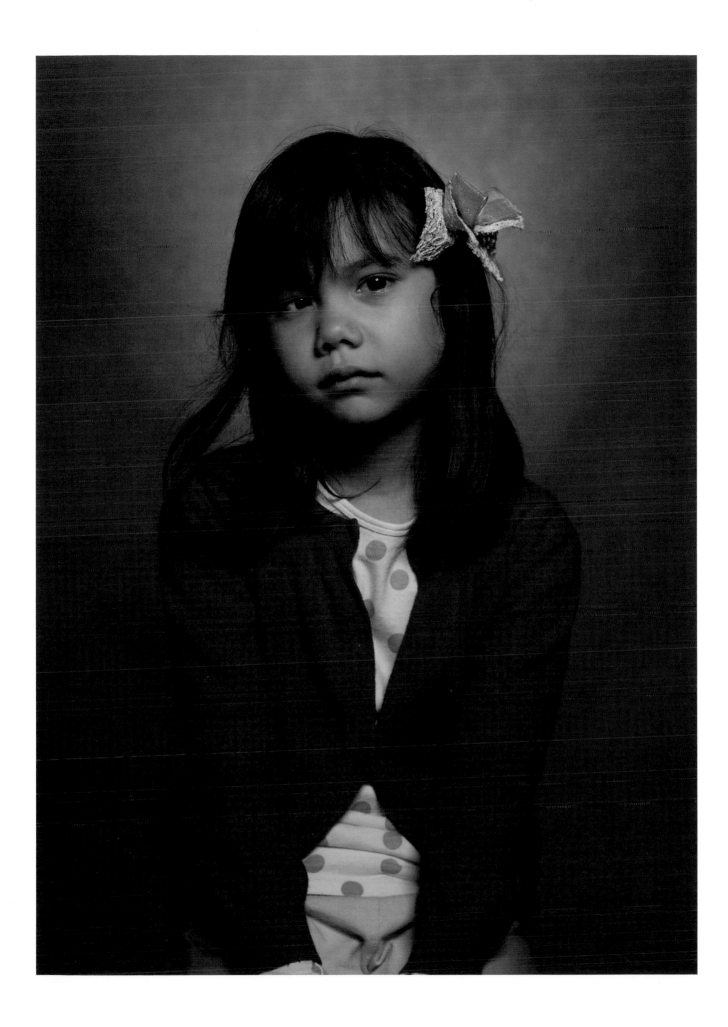

Tristan Pyotrovich Benetka
Great-great-great-grandson
Born 2008

Descendant of Lev Nikolayevich Tolstoy's ninth born,
Andrey Lvovich

Lives in Czech Republic
REF. 332

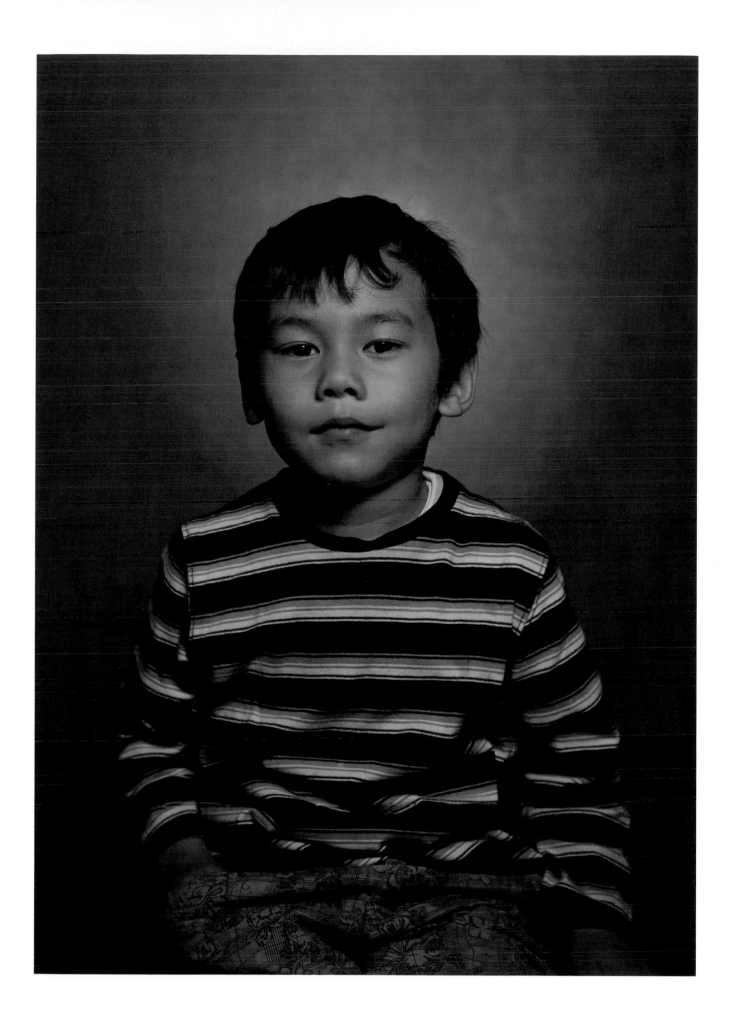

Jana Vladimirovna Benetka (Benetkova)
Great-great-granddaughter
Born 1970

Descendant of Lev Nikolayevich Tolstoy's ninth born,
Andrey Lvovich

Lives in Czech Republic
Graphic designer and DTP operator
REF. 186

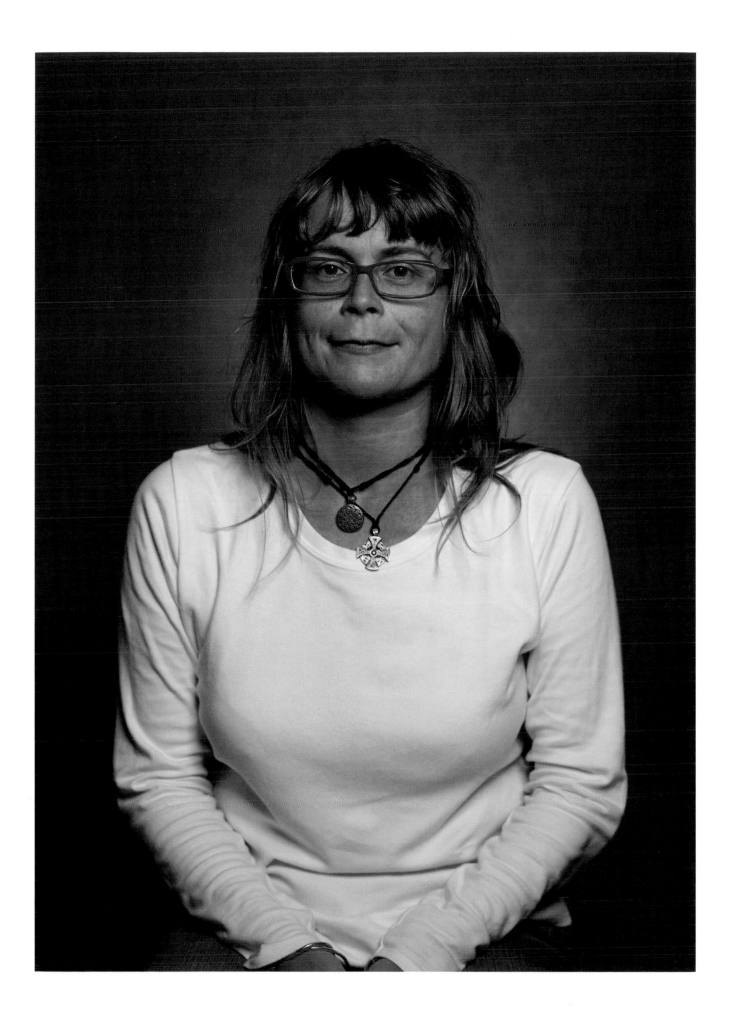

Sophia Petrovna Penkrat
Great-great-granddaughter
Born 1976

Descendant of Lev Nikolayevich Tolstoy's tenth born,
Mikhail Lvovich

Lives in USA
Associate creative director
REF. 194

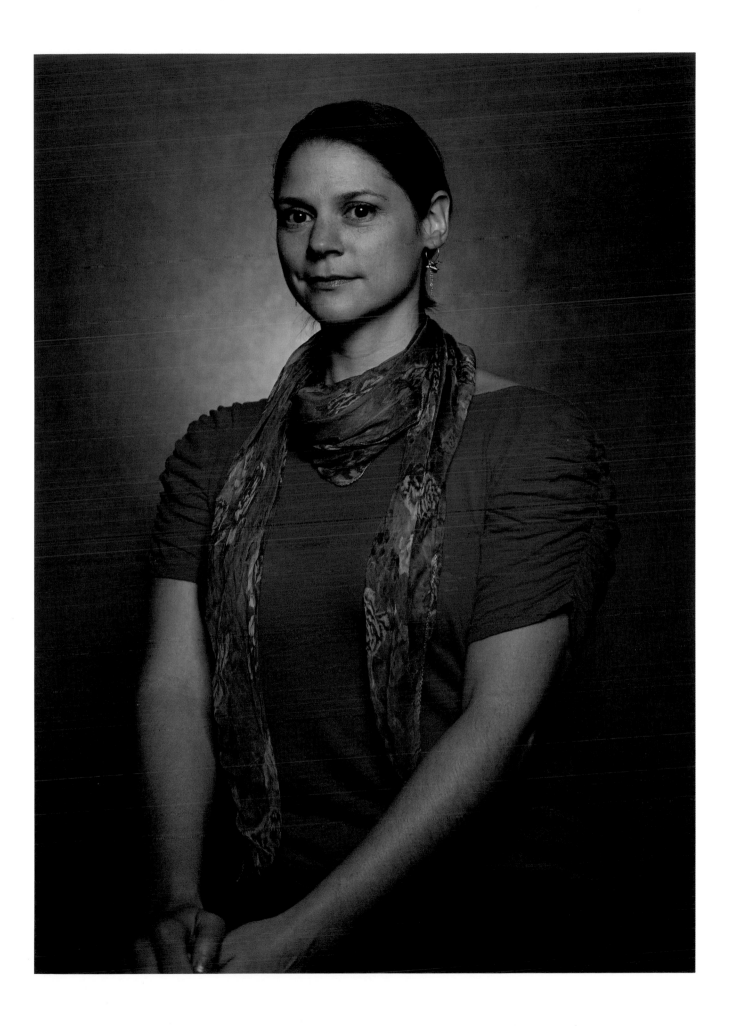

Maria Vladimirovna Sarandinaki
Great-granddaughter
Born 1951

Descendant of Lev Nikolayevich Tolstoy's tenth born,
Mikhail Lvovich

Lives in USA
Retired Executive Director, Hermitage Museum Foundation
REF. 92

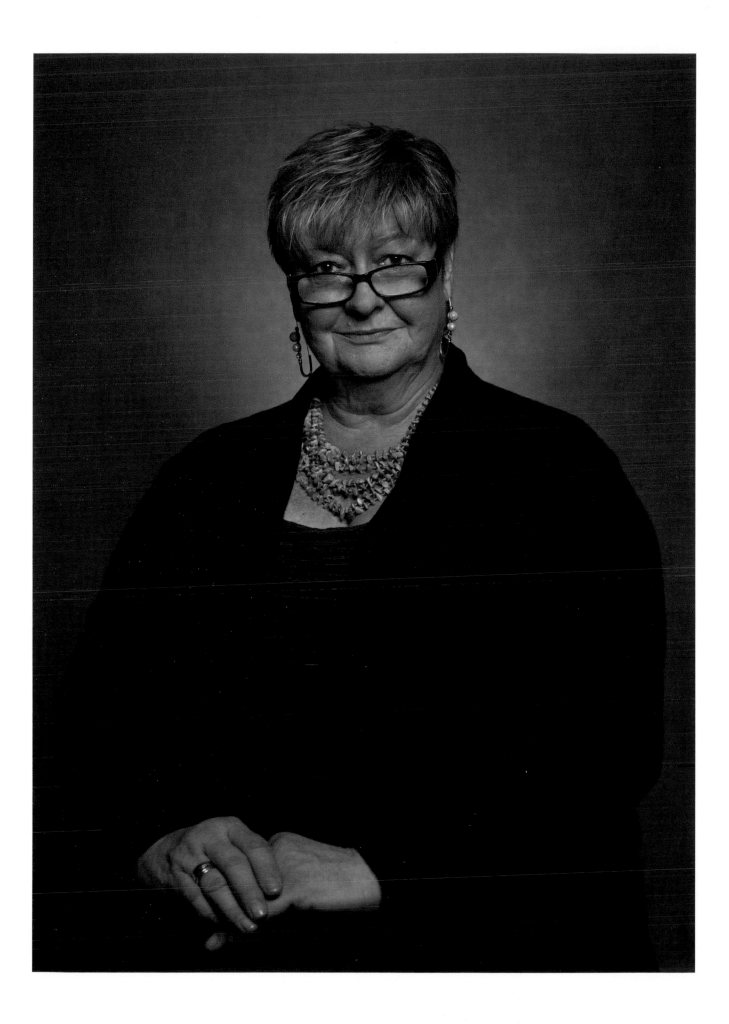

Alexander Petrovich Sarandinaki
Great-great-grandson
Born 1979

Descendant of Lev Nikolayevich Tolstoy's tenth born,
Mikhail Lvovich

Lives in USA
Non-commissioned officer, United States Marine Corps
REF. 195

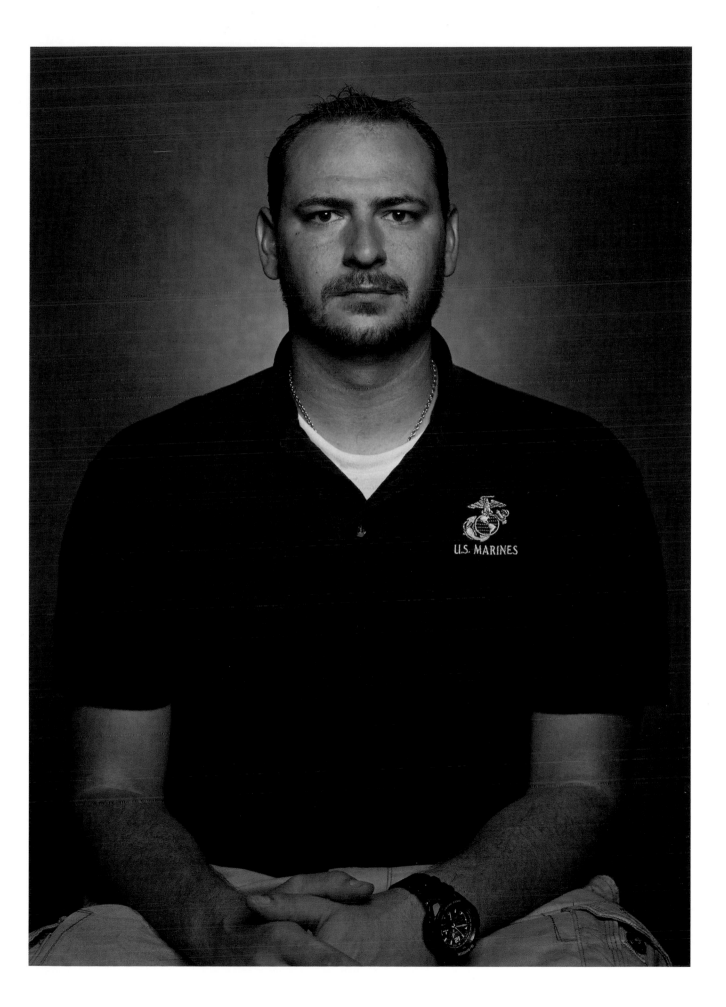

Tatiana Petrovna Sarandinaki
Great-great-granddaughter
Born 1981

Descendant of Lev Nikolayevich Tolstoy's tenth born,
Mikhail Lvovich

Lives in USA
Banker
REF. 196

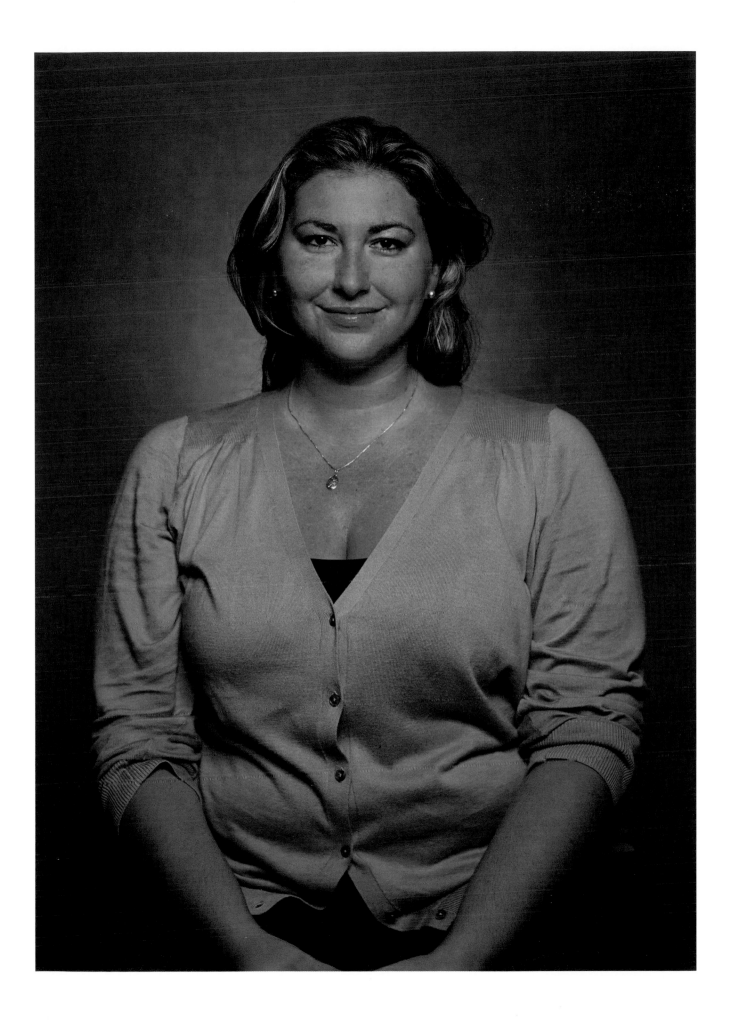

Sergei Petrovich Sarandinaki
Great-great-grandson
Born 1989

Descendant of Lev Nikolayevich Tolstoy's tenth born,
Mikhail Lvovich

Lives in USA
Recent graduate of the School of International Service,
American University, Washington, D.C.
REF. 197

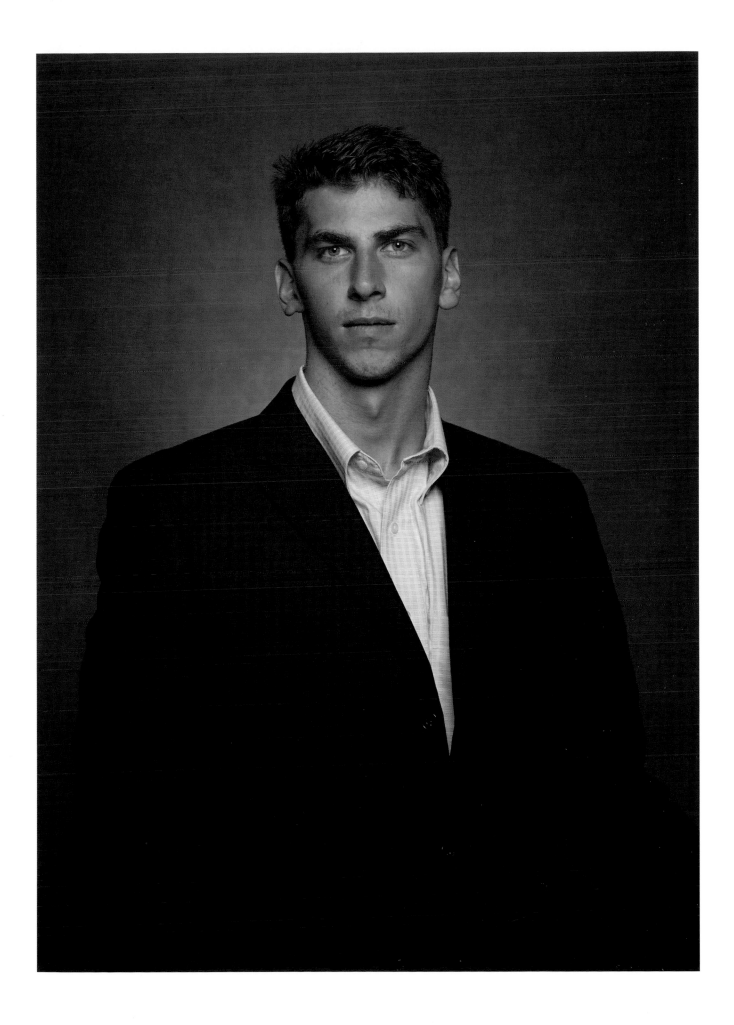

Mikhail Yurevich Alekseev
Great-great-grandson
Born 1954

Descendant of Lev Nikolayevich Tolstoy's tenth born,
Mikhail Lvovich

Lives in Russia
Designer
REF. 198

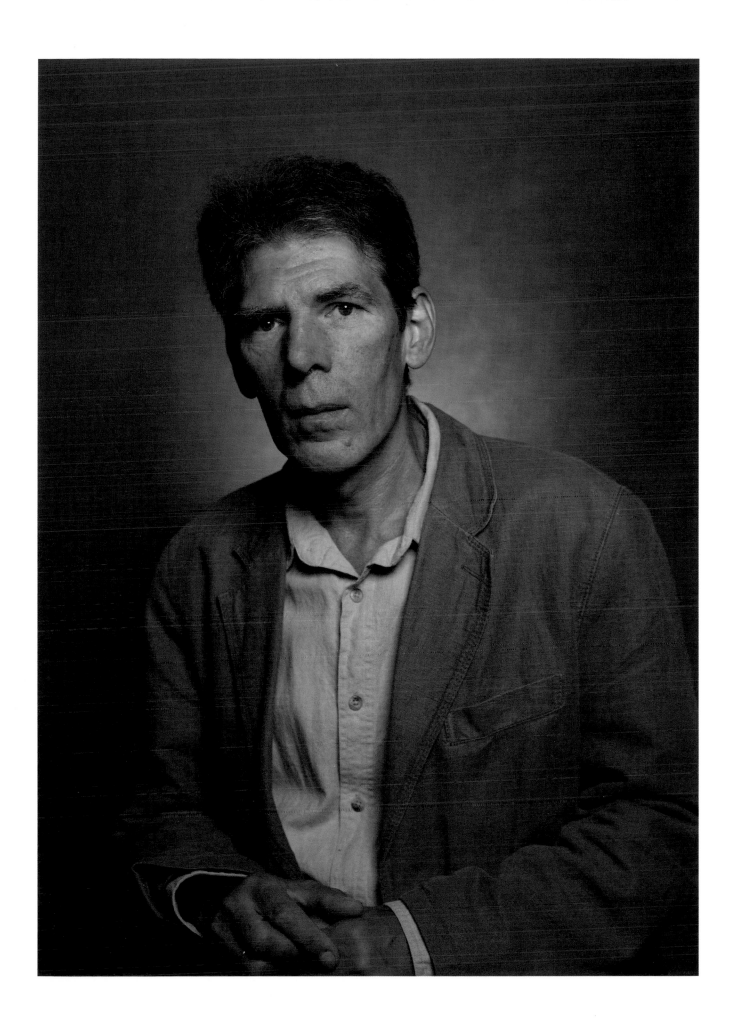

Ekaterina Mikhailovna Alekseeva (Mazhaeva)
Great-great-great-granddaughter
Born 1974

Descendant of Lev Nikolayevich Tolstoy's tenth born,
Mikhail Lvovich

Lives in Russia
Journalist
REF. 345

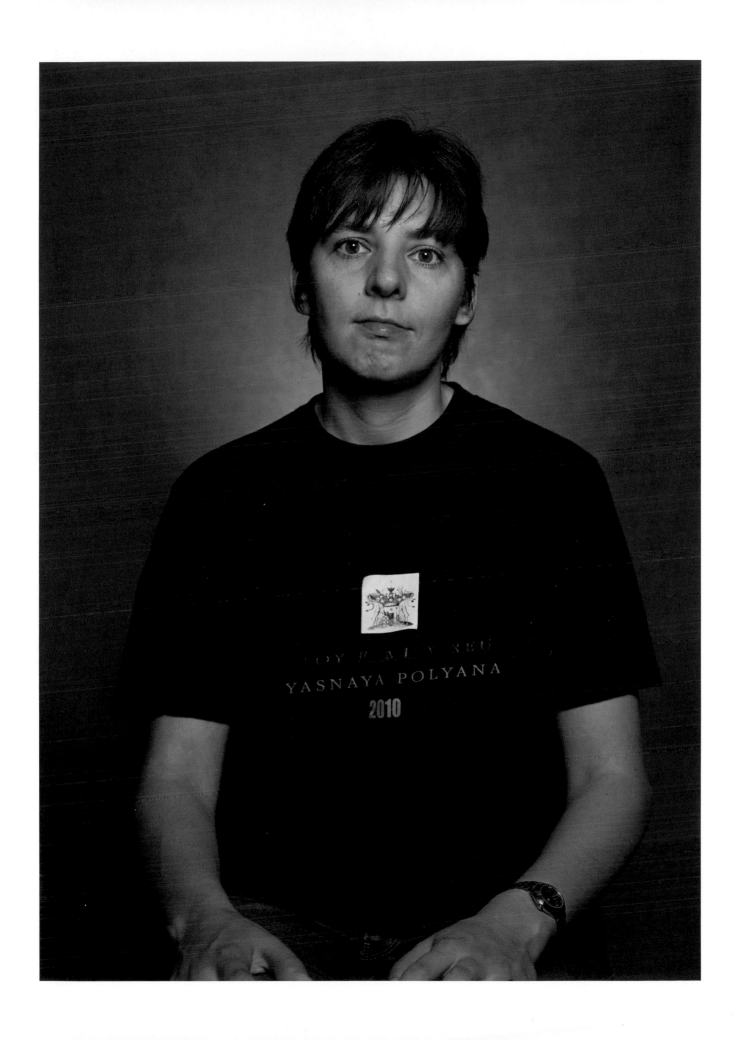

Dmitry Alexeevich Mazhaev
Great-great-great-great-grandson
Born 2001

Descendant of Lev Nikolayevich Tolstoy's tenth born,
Mikhail Lvovich

Lives in Russia
REF. 372

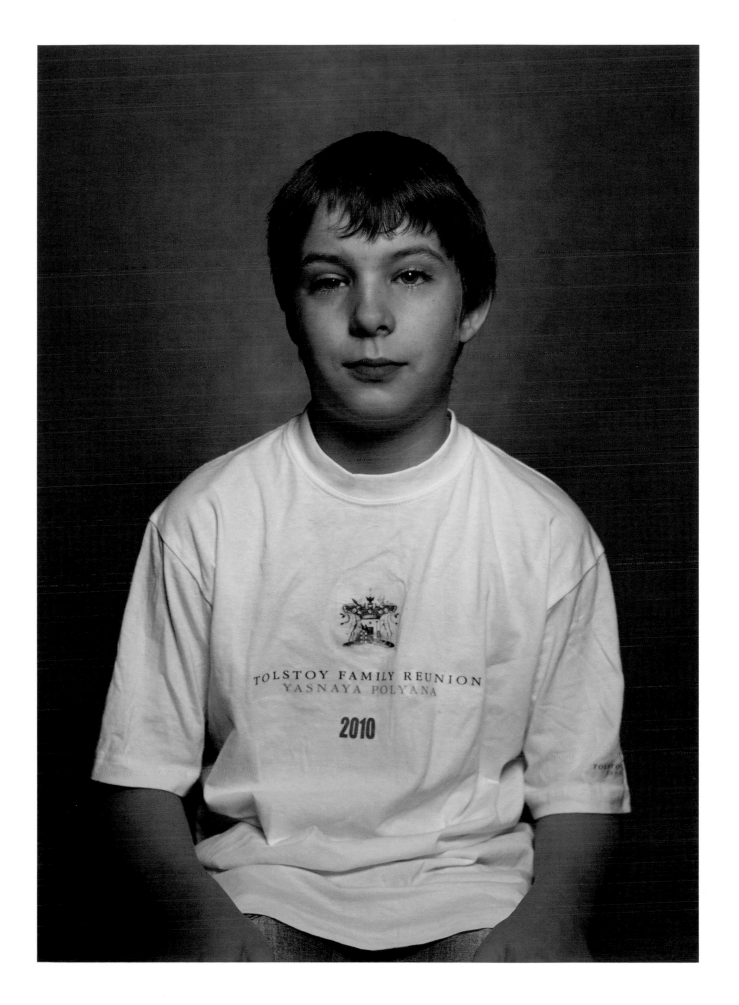

Sergey Alexeevich Mazhaev
Great-great-great-great-grandson
Born 2007

Descendant of Lev Nikolayevich Tolstoy's tenth born,
Mikhail Lvovich

Lives in Russia
REF. 373

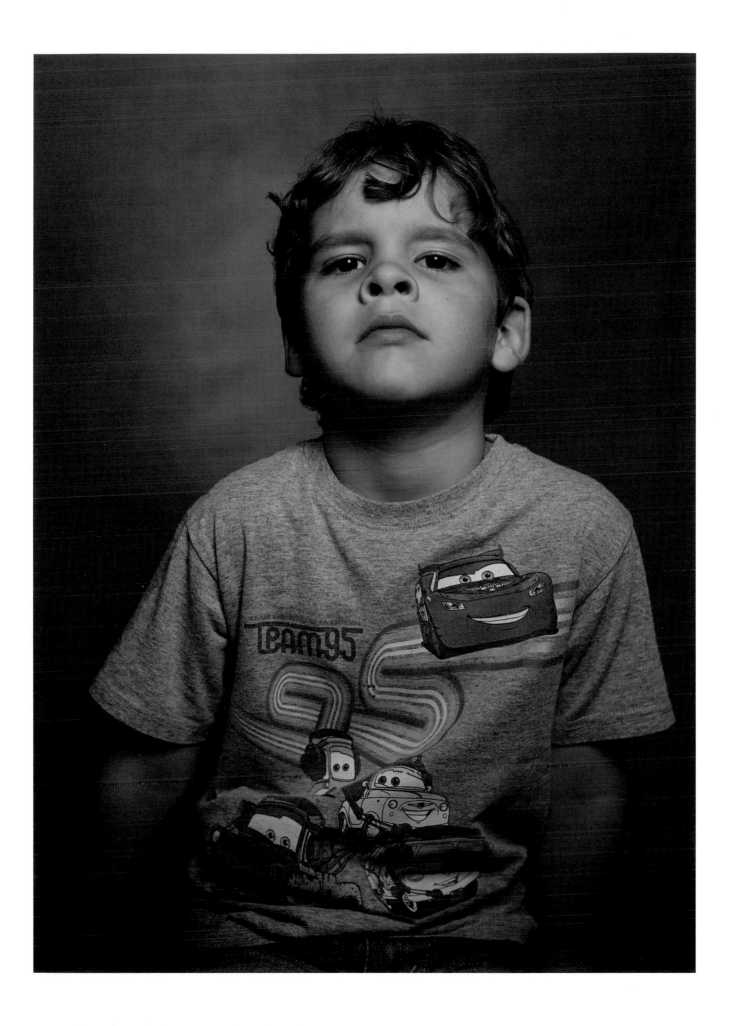

Yekaterina Sergeyevna Lopukhina Potapova
Great-great-granddaughter
Born 1980

Descendant of Lev Nikolayevich Tolstoy's tenth born,
Mikhail Lvovich

Lives in USA
Operations director in business media
REF. 212

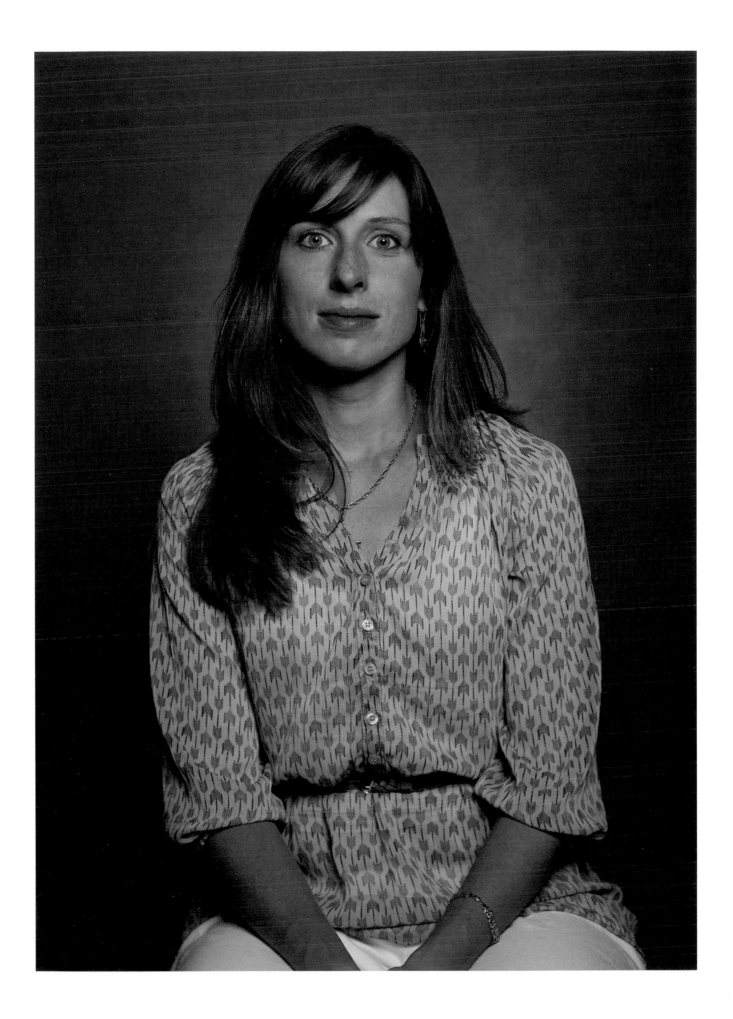

Alexandra Nikitichna Lopukhina
Great-great-granddaughter
Born 1977

Descendant of Lev Nikolayevich Tolstoy's tenth born,
Mikhail Lvovich

Lives in Canada
Director of Communications and Marketing, Amnesty
International Canada
REF. 214

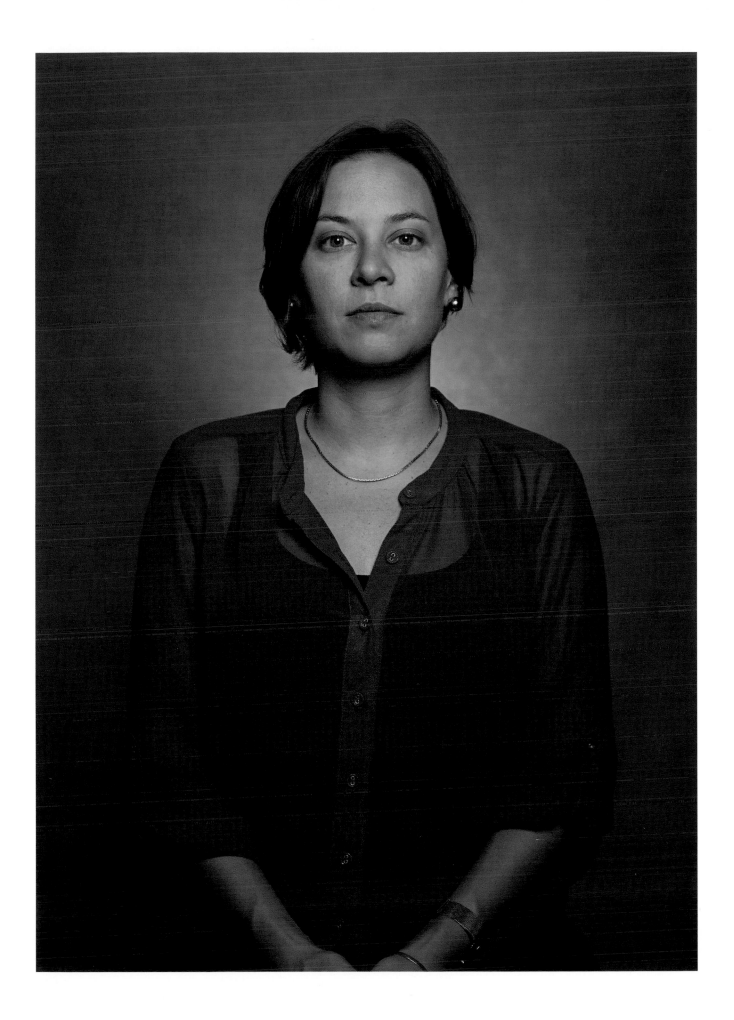

Lev Nikolaevich Tolstoy
Great-grandson of Sergey Nikolayevich Tolstoy, brother
of Lev Nikolayevich Tolstoy
Born 1935

Lives in Ukraine
Retired major general, Kremlin Regiment

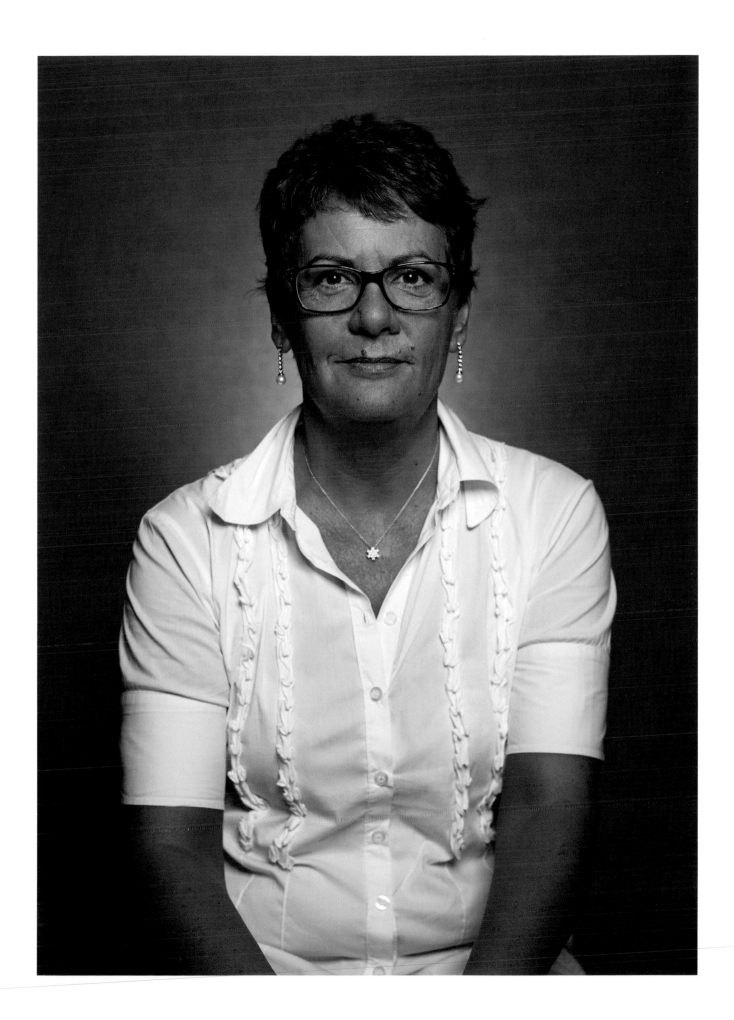

Svetlana Mikhailovna Tolstaya
Wife of Nikita Ilych Tolstoy (deceased 1996; ref. 53)
and mother of Marfa Nikitichna Tolstaya (see p. 36)
and Anna (Fiokla) Nikitichna Tolstaya (see p. 38)
Born 1938

Lives in Russia
Professor of Philological Sciences

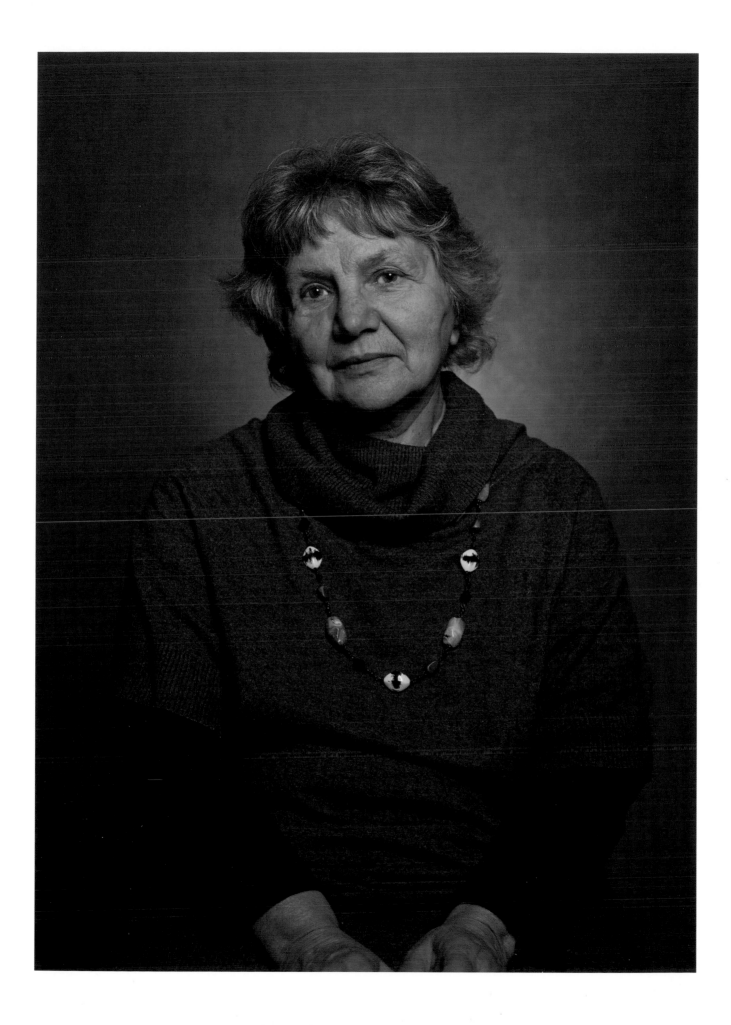

Galina Evgenievna Lysiakova
Wife of Ivan Vladimirovich Lysiakov (see p. 42) and
mother of Oleg Ivanovich Lysiakov (see p. 44)
Born 1980

Lives in Russia
Graphic designer

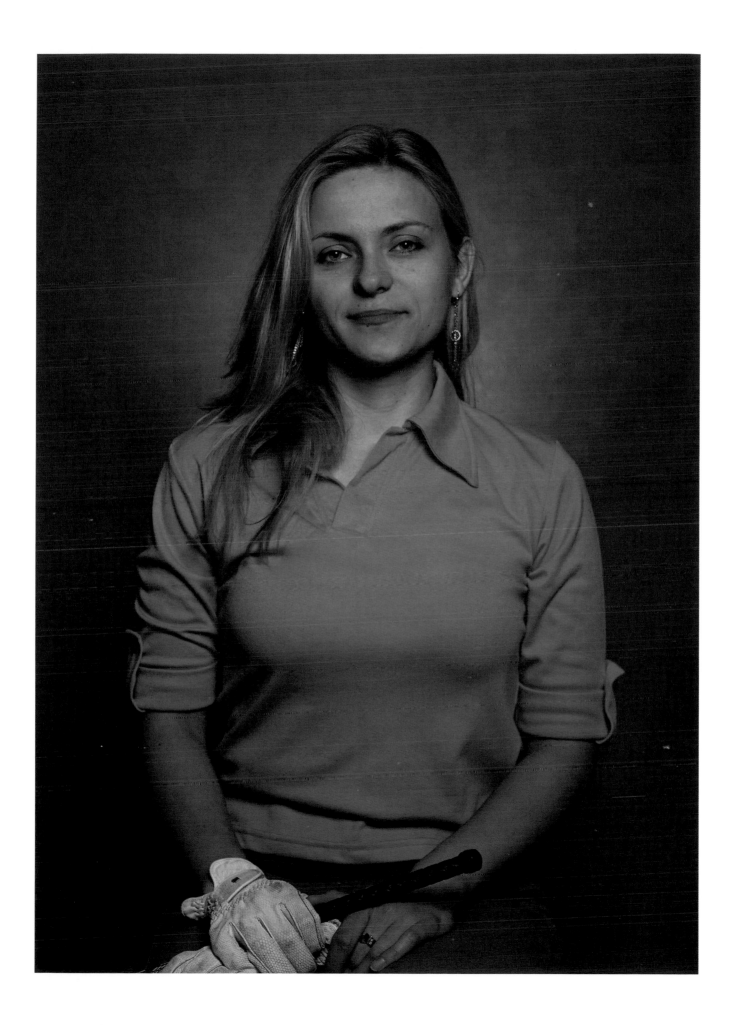

Daria Evgenievna Tolstaya
Wife of Petr Olegovich Tolstoy (see p. 46) and
mother of Aleksandra Petrovna Tolstaya (see p. 48)
Born 1969

Lives in Russia
Journalist

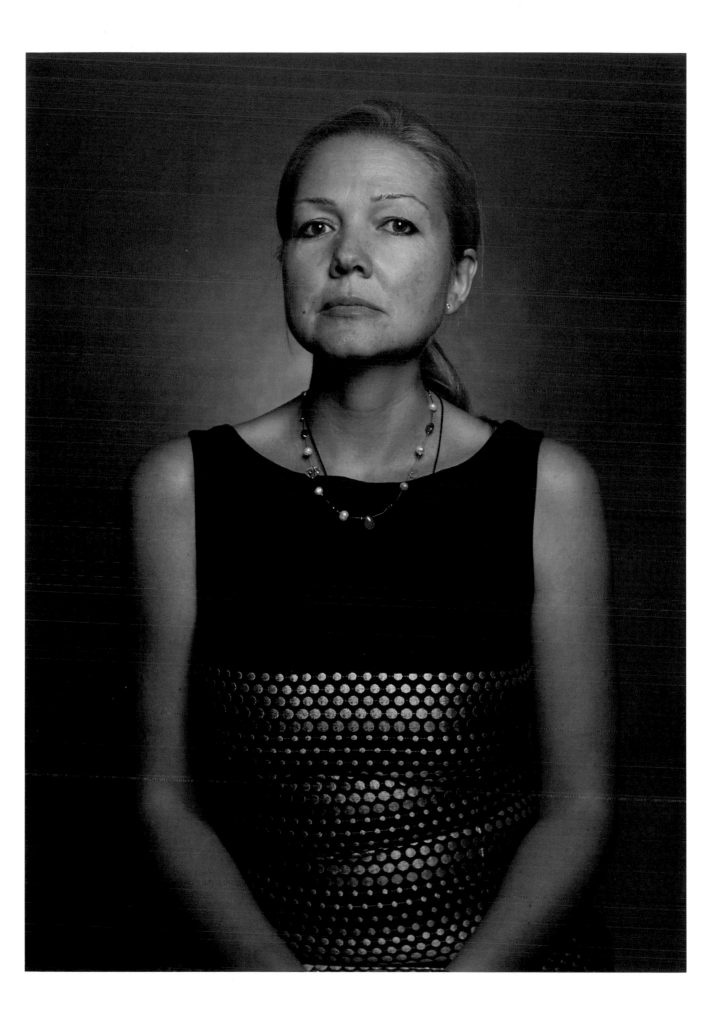

Rita Aleksandrovna Tolstaya (née Karpenko)
First wife of Ilya Vladimirovich Tolstoy (deceased 1997; ref. 55)
and mother of Ilya Ilych Tolstoy (see p. 50) and
Vladimir Ilych Tolstoy (see p. 58)
Born 1930

Lives in Russia
Retired Professor of Russian Language, Centre for
International Studies, Lomonosov Moscow State University

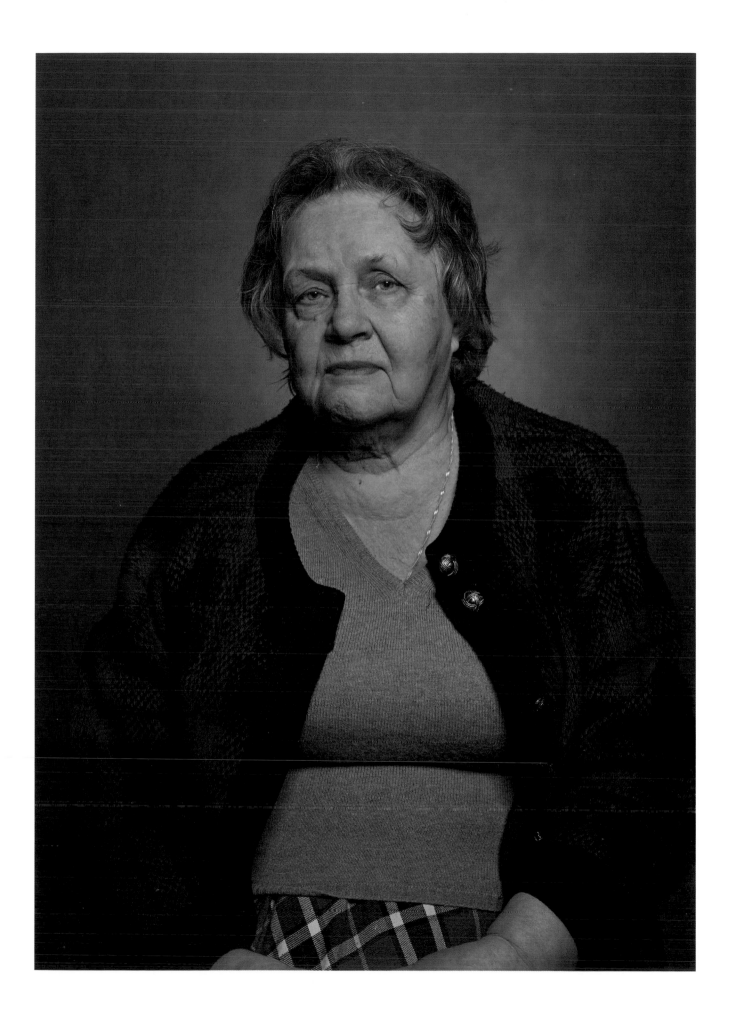

Kirill Mikhailovich Voroviov
Husband of Anna Ilyinichna Tolstaya (see p. 52)
Born 1967

Lives in Russia
Businessman

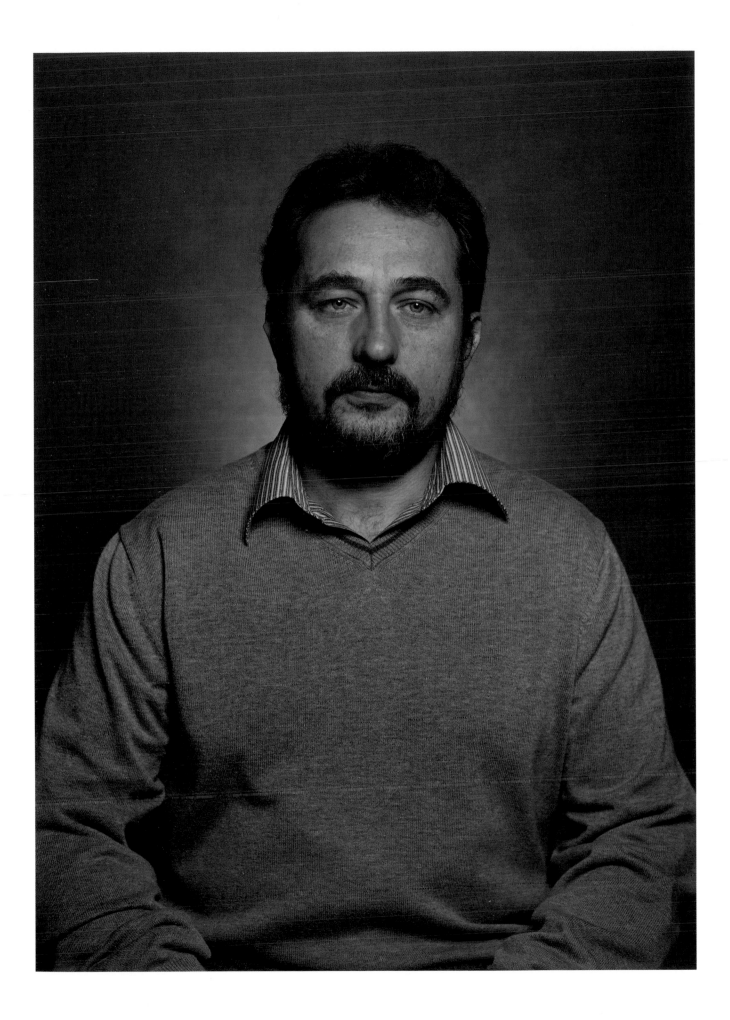

Ekaterina Aleksandrovna Tolstaya (née Minayeva)
Wife of Vladimir Ilych Tolstoy (see p. 58) and
mother of Andrei Vladimirovich Tolstoy (see p. 64)
and Ivan Vladimirovich Tolstoy (see p. 66)
Born 1972

Lives in Russia
Director, Yasnaya Polyana Museum-Estate

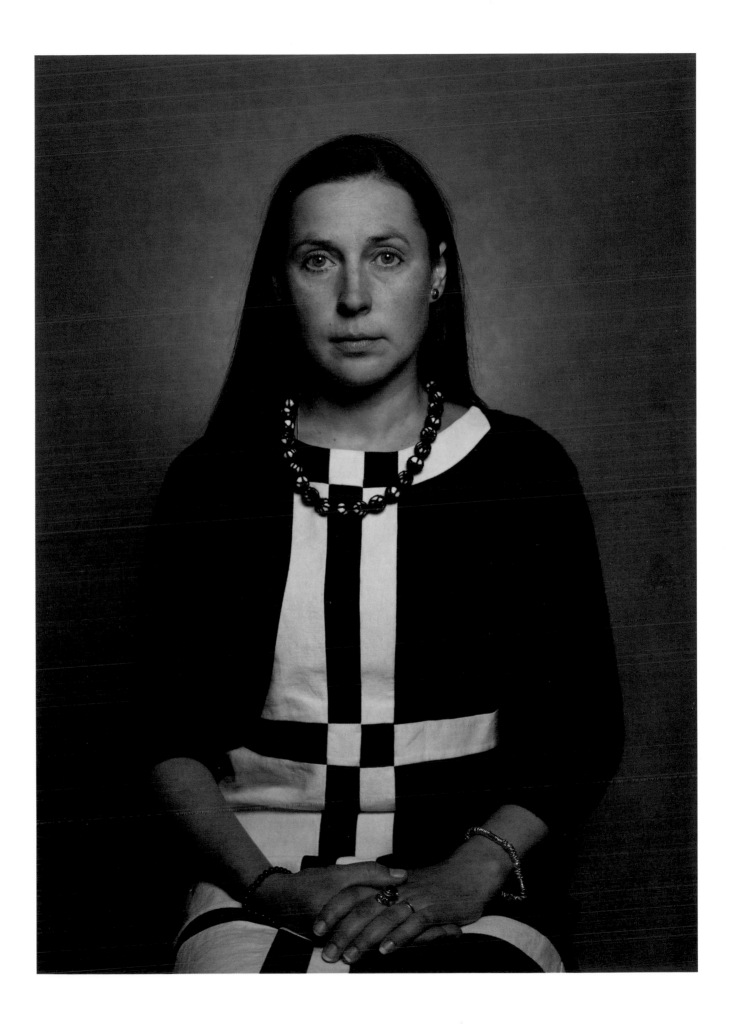

Nina (Rutger) Tolstoy
Wife of Daniil Nikitich Tolstoy (see p. 72) and
mother of Anastasia Daniilovna Tolstoy (see p. 74)

Lives in Sweden

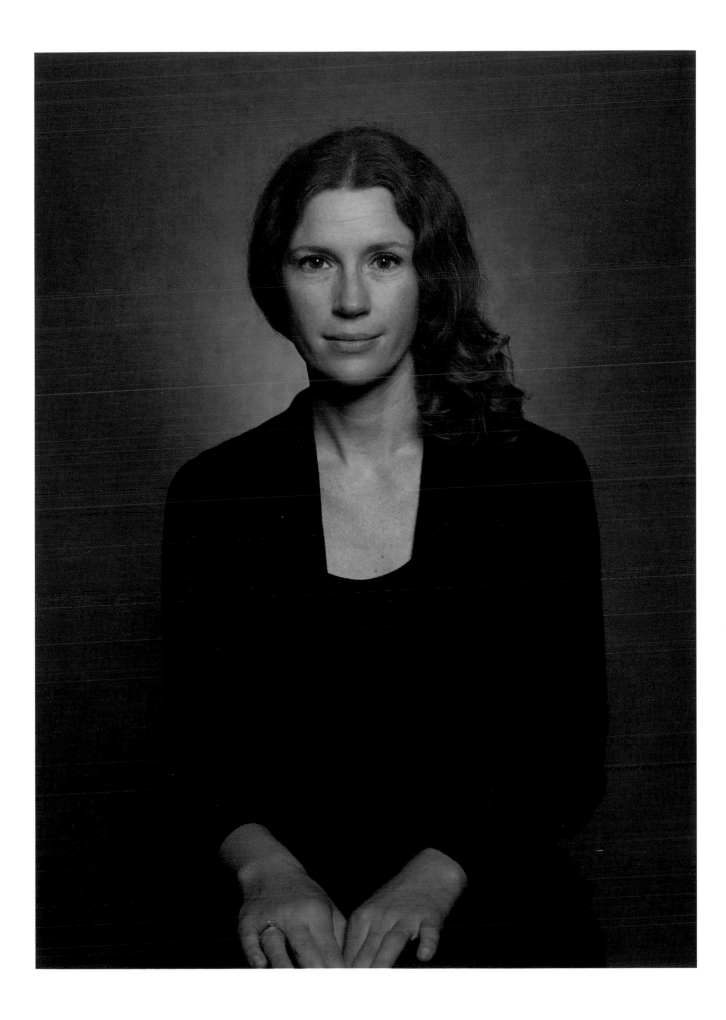

Kerstin Nilsson Lundeberg
Wife of Staffan Lundeberg (ref. 71) and mother
of Catarina Lundeberg Hjort (see p. 76)
Born 1937

Lives in Sweden

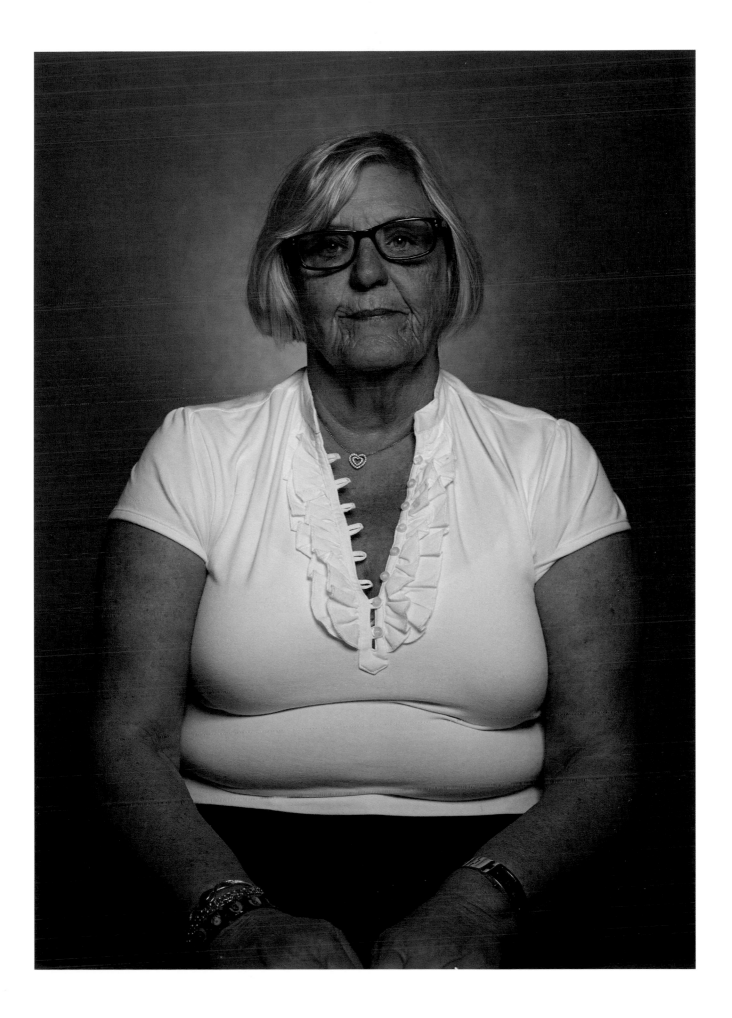

Margarita Edvik
Cousin of Kerstin Nilsson Lundeberg
(wife of Staffan Lundeberg; see p. 142)
Born 1950

Lives in Sweden

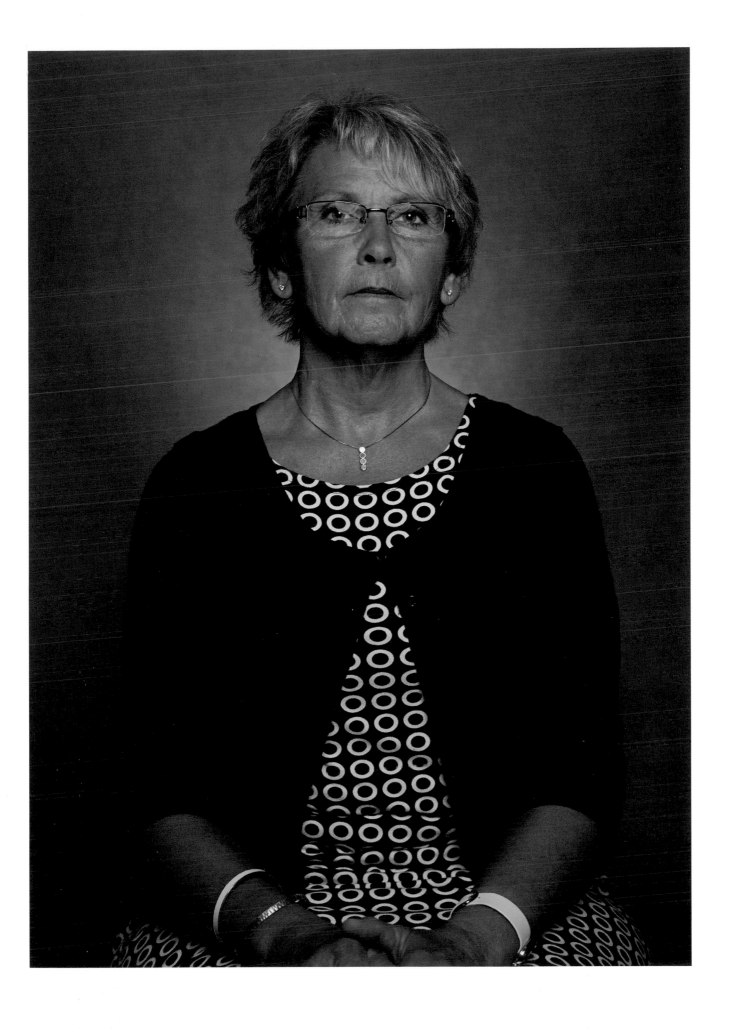

Bjorn Bergström
Husband of Signe Bergström (see p. 80) and
father of Ylva (Bergström) Berling-Pesant (see p. 82)
Born 1938

Lives in Sweden
Retired radiologist

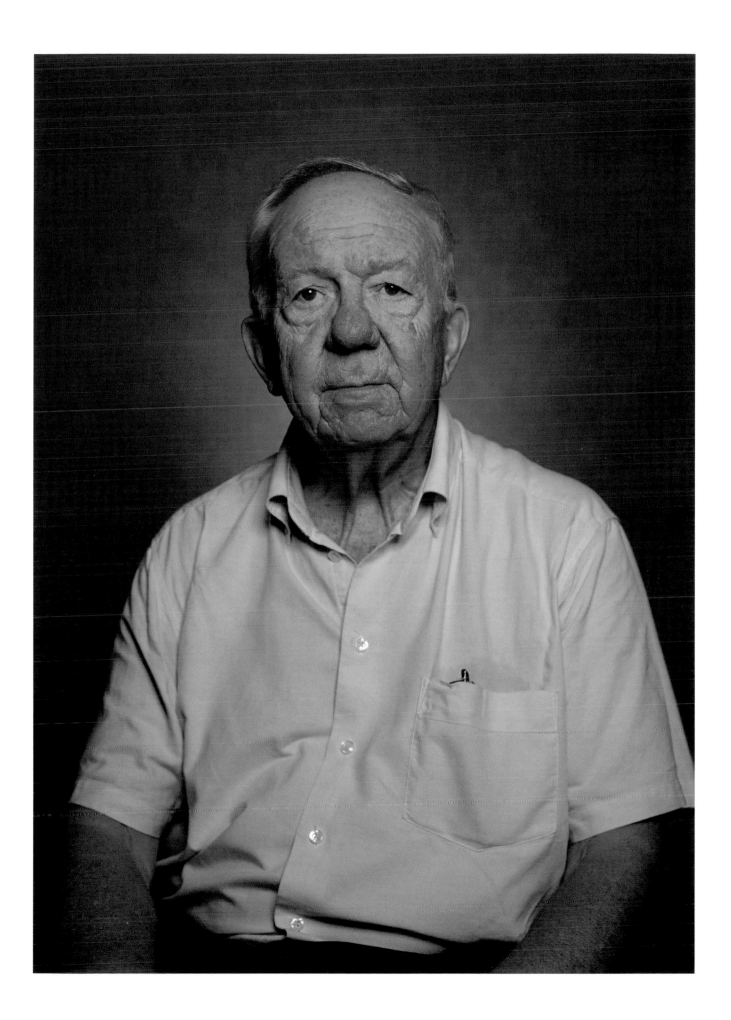

Etienne Berling-Pesant
Husband of Ylva (Bergström) Berling-Pesant (see p. 82)
and father of Oscar Berling-Pesant (see p. 84)
Born 1963

Lives in France
E-learning consultant

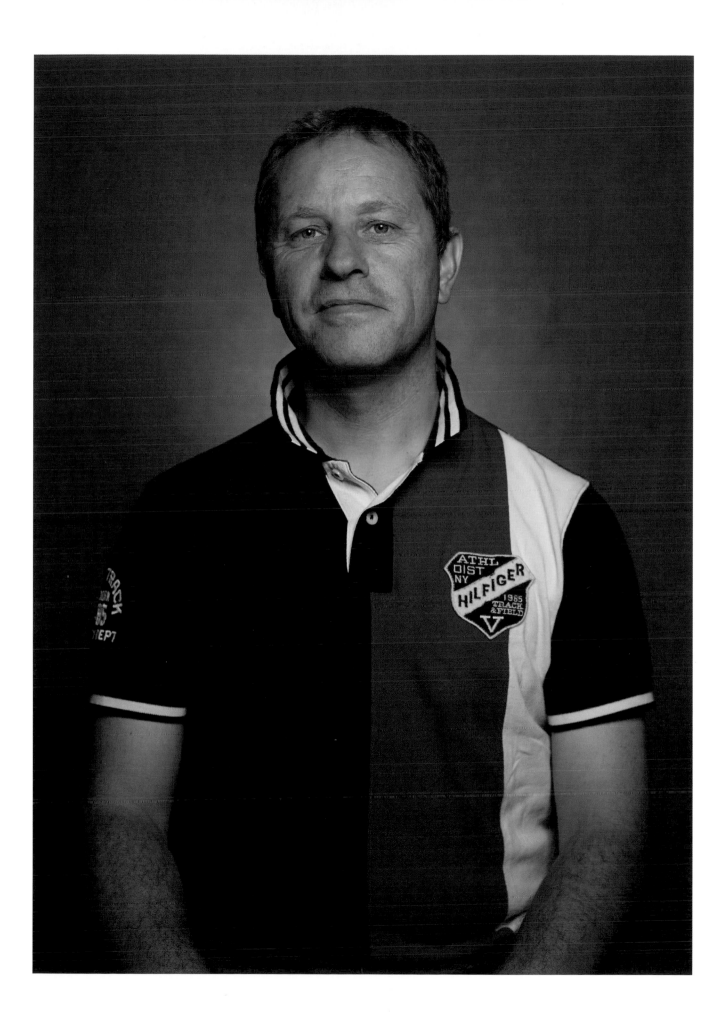

Jan-Eric Bergmark
Husband of Anne-Charlotte Ceder Bergmark (see p. 86)
and father of Carl Per Eric Effert Bergmark (see p. 88)
Born 1943

Lives in Sweden
Retired mining and steelworks manager

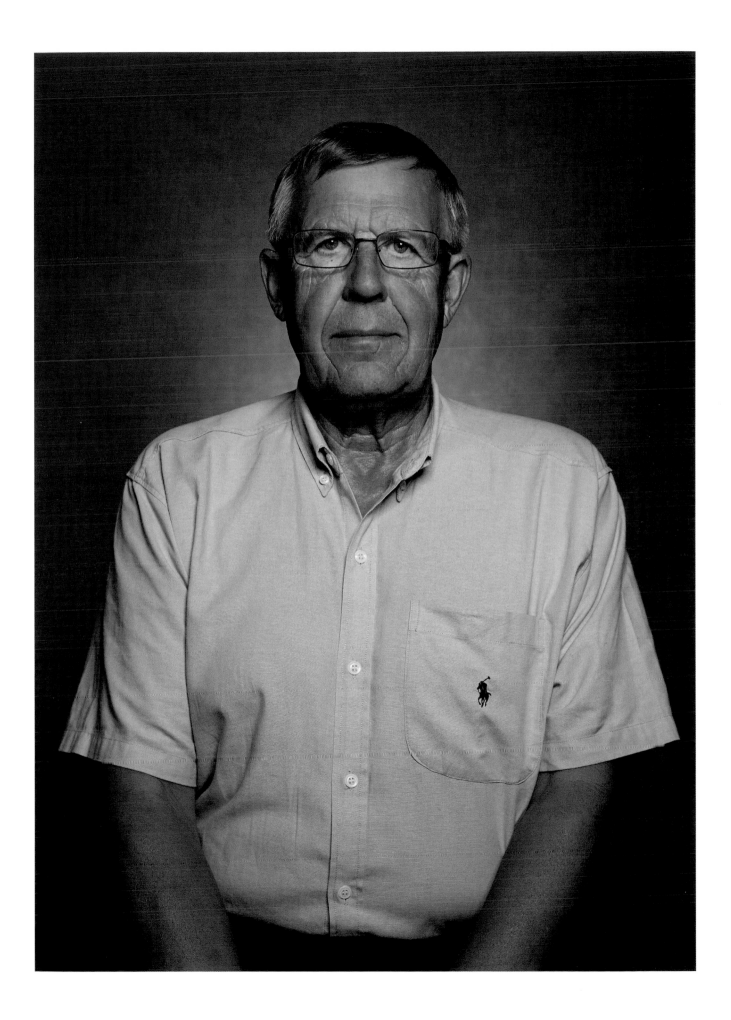

Kristina Linins (née Lundeberg)
Cousin of Jan-Eric Bergmark
(husband of Anne-Charlotte Ceder Bergmark; see p. 150)
Born 1944

Lives in Sweden
Retired company director

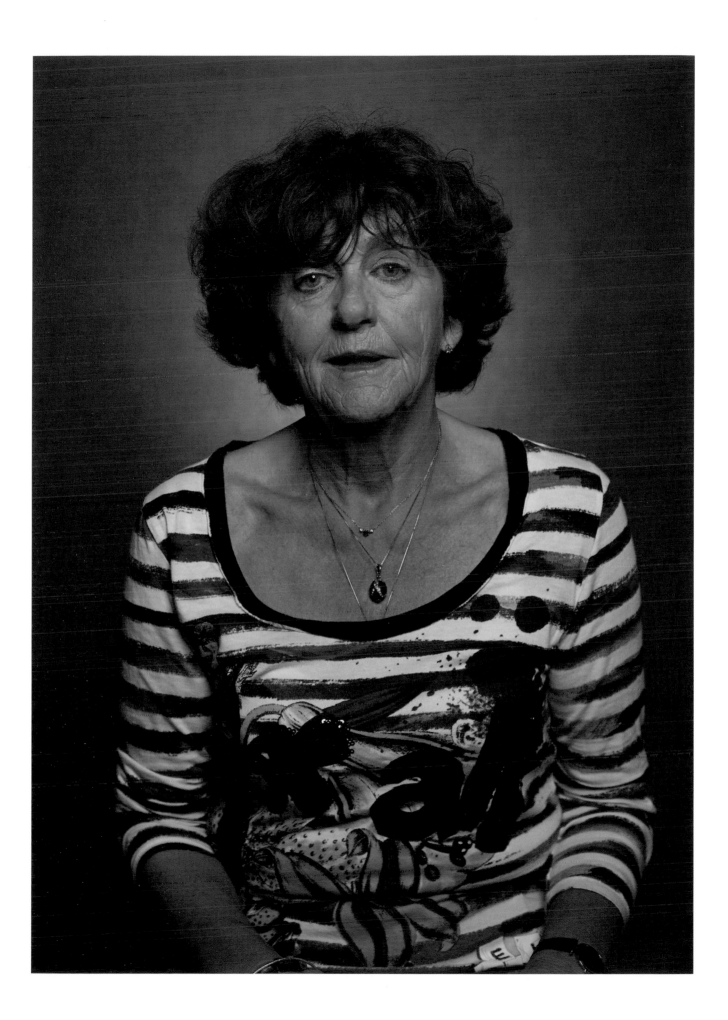

Johanna Effert
Wife of Carl Per Eric Effert Bergmark (see p. 88)
and mother of Carl Leo Eric Effert (see p. 90) and
Carl Axel Nikolaj Effert (see p. 92)
Born 1971

Lives in Sweden

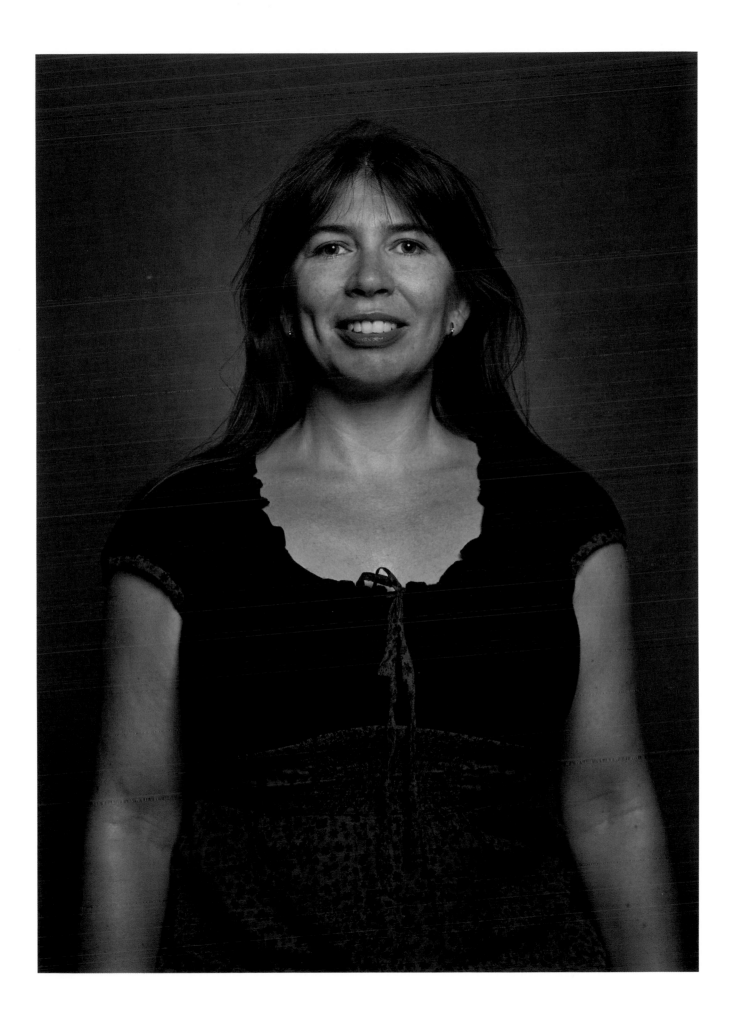

Sirinta Benetka
Wife of Pyotr Vladimirovich Benekta (see p. 94) and
mother of Nela Pyotrovna Benetka (see p. 96)
and Tristan Pyotrovich Benetka (see p. 98)
Born 1973

Lives in Czech Republic
Housewife

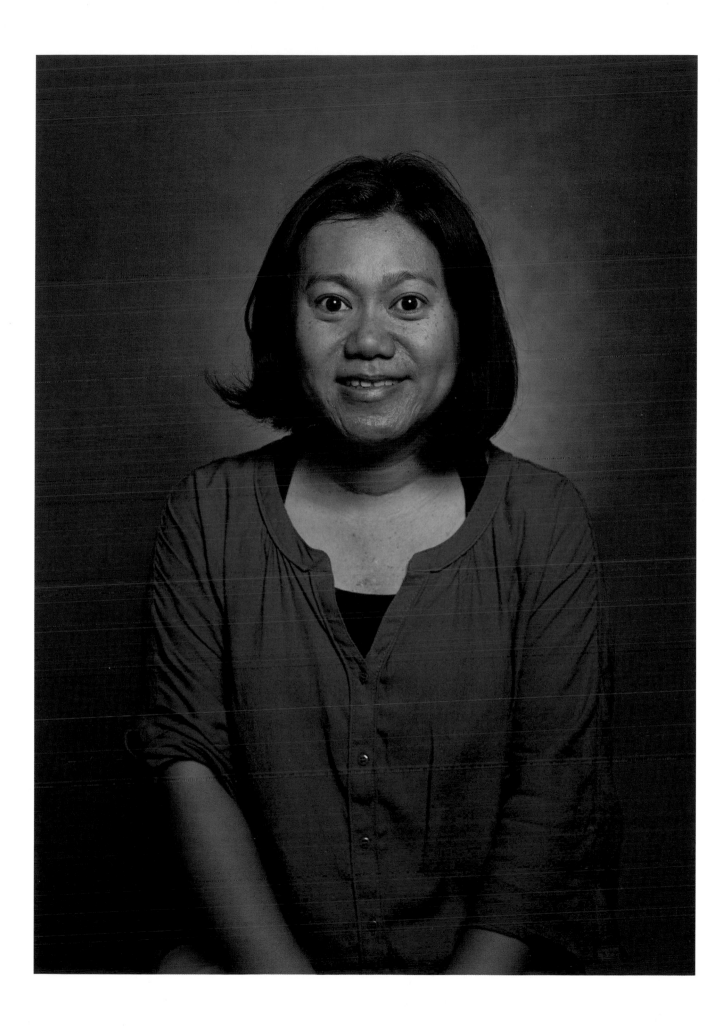

Peter Alexandrovich Sarandinaki
Husband of Maria Vladimirovna Sarandinaki (see p. 104)
and father of Alexander Petrovich Sarandinaki (see p. 106),
Tatiana Petrovna Sarandinaki (see p. 108) and
Sergei Petrovich Sarandinaki (see p. 110)
Born 1950

Lives in USA
Retired sea captain

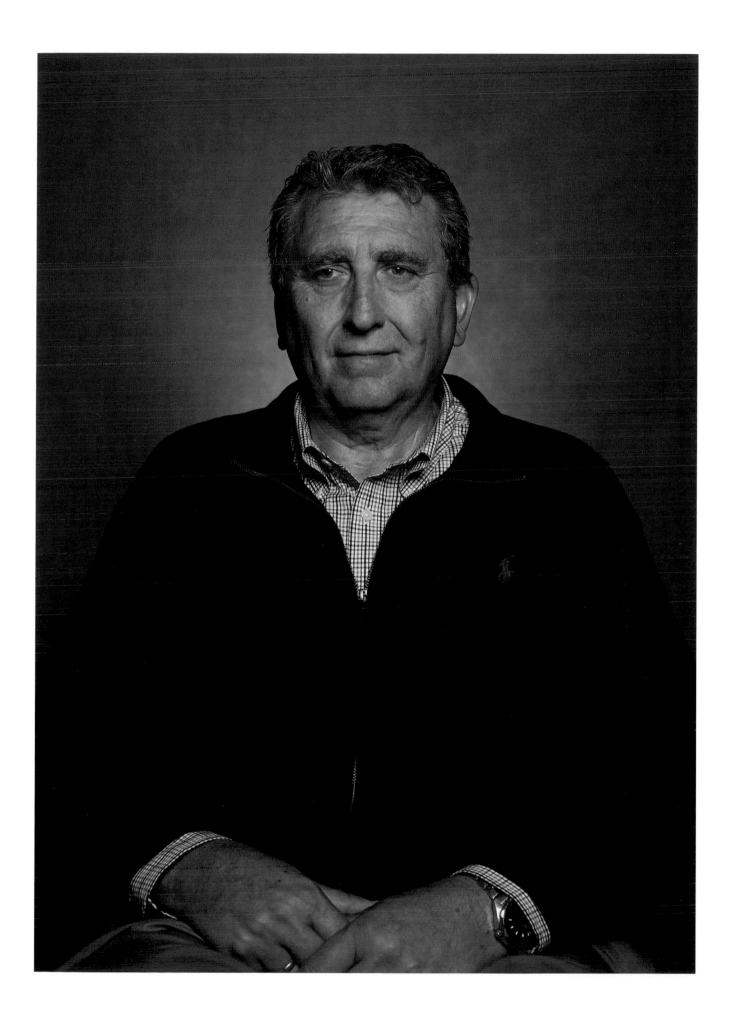

Marina Vladimirovna Alekseeva
Wife of Mikhail Yurevich Alekseev (see p. 112)
Born 1963

Lives in Russia
Psychologist

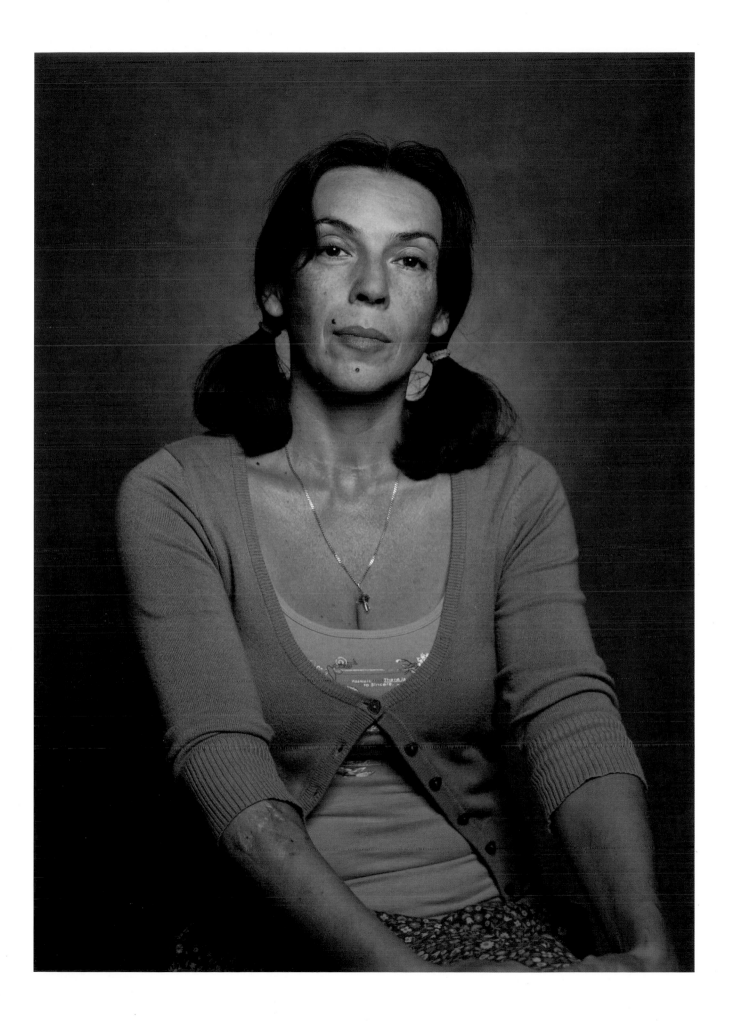

Aleksei Igorevich Mazhaev
Husband of Ekaterina Mikhailovna Alekseeva (Mazhaeva)
(see p. 114) and father of Dmitry Alexeevich Mazhaev
(see p. 116) and Sergei Alexeevich Mazhaev (see p. 118)
Born 1972

Lives in Russia
Journalist and editor

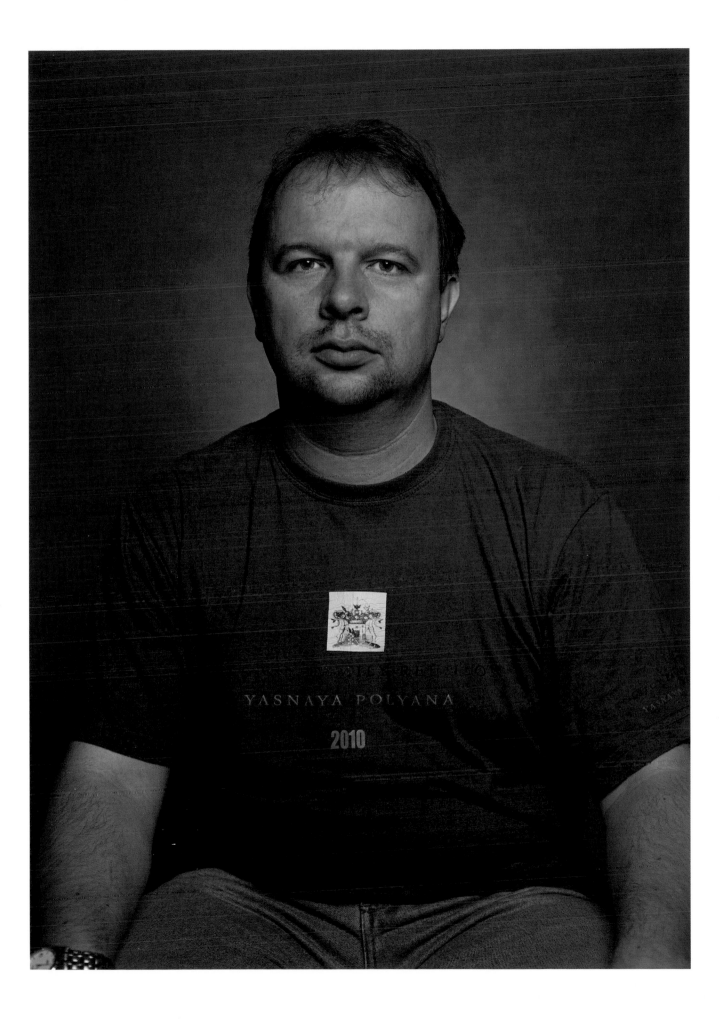

Sergey Potapov
Husband of Yekaterina Sergeyevna Lopukhina Potapova
(see p. 120)
Born 1977

Lives in USA
Federal law enforcement officer, US Department
of Homeland Security

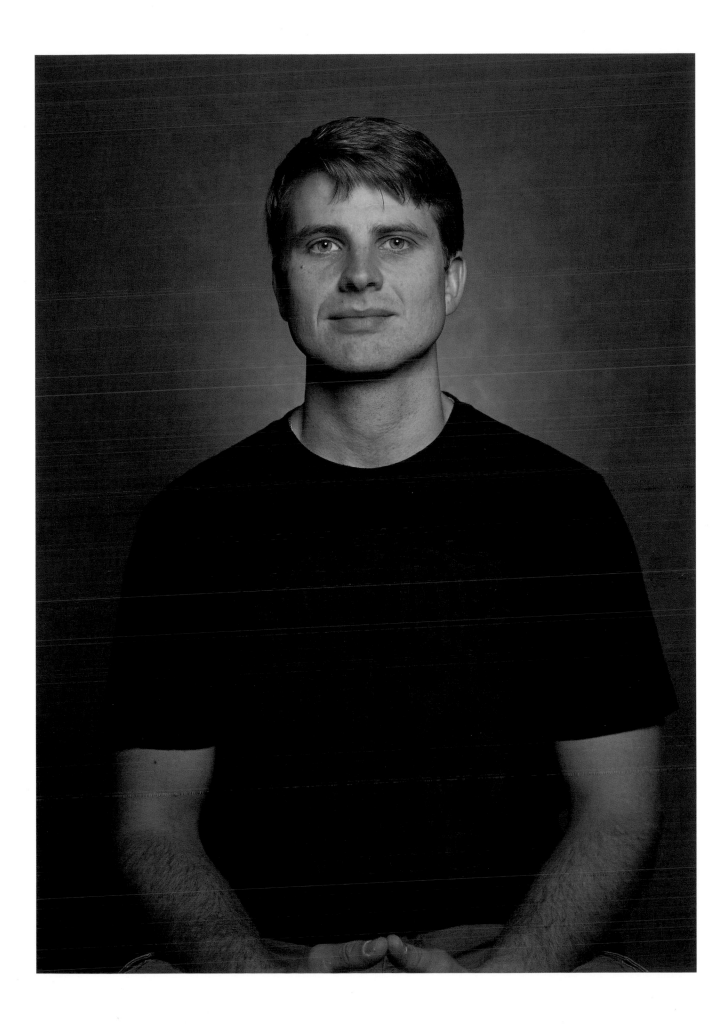

Nikolai Dmitrievich Tolstoy-Miloslavsky
Head of the senior line of the Tolstoy family
Born 1935

Lives in England
Historian and author

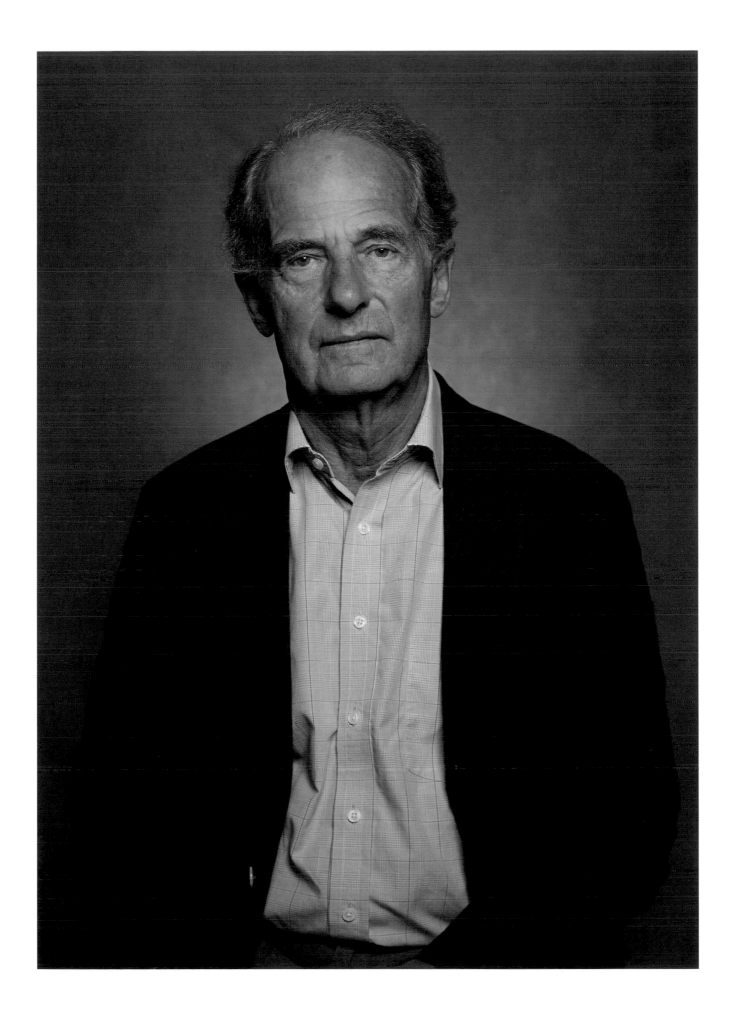

Dmitry Nikolaevich Tolstoy-Miloslavsky
Born 1978

Lives in England
Historian and tutor

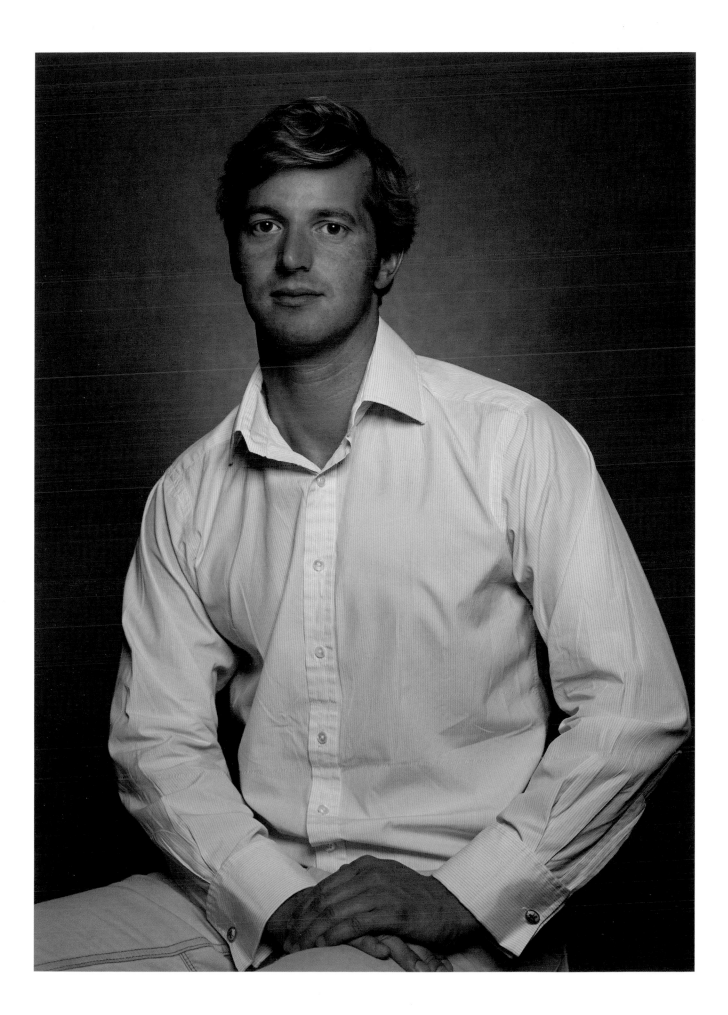

Andrei Dmitrievich Tolstoy-Miloslavsky
Born 1949

Lives in Russia
Chairman of the War and Peace Ball

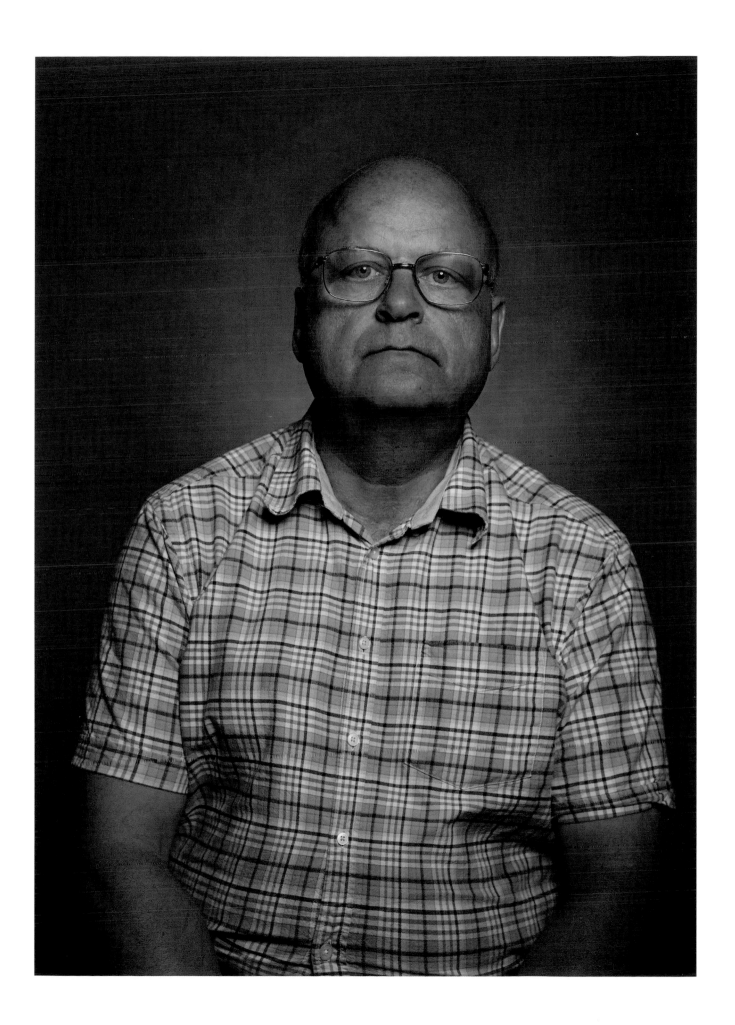

Igor Andreevich Tolstoy-Miloslavsky
Born 1985

Lives in England
Country estate director

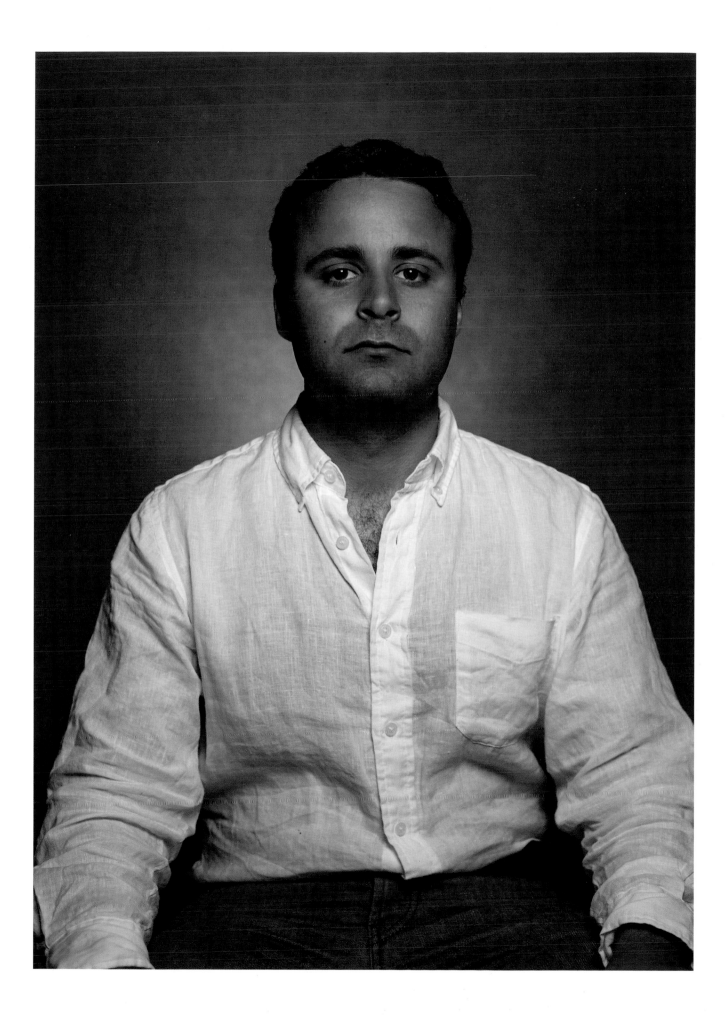

Oleg Andreevich Tolstoy-Miloslavsky
Born 1986

Lives in England
Photographer

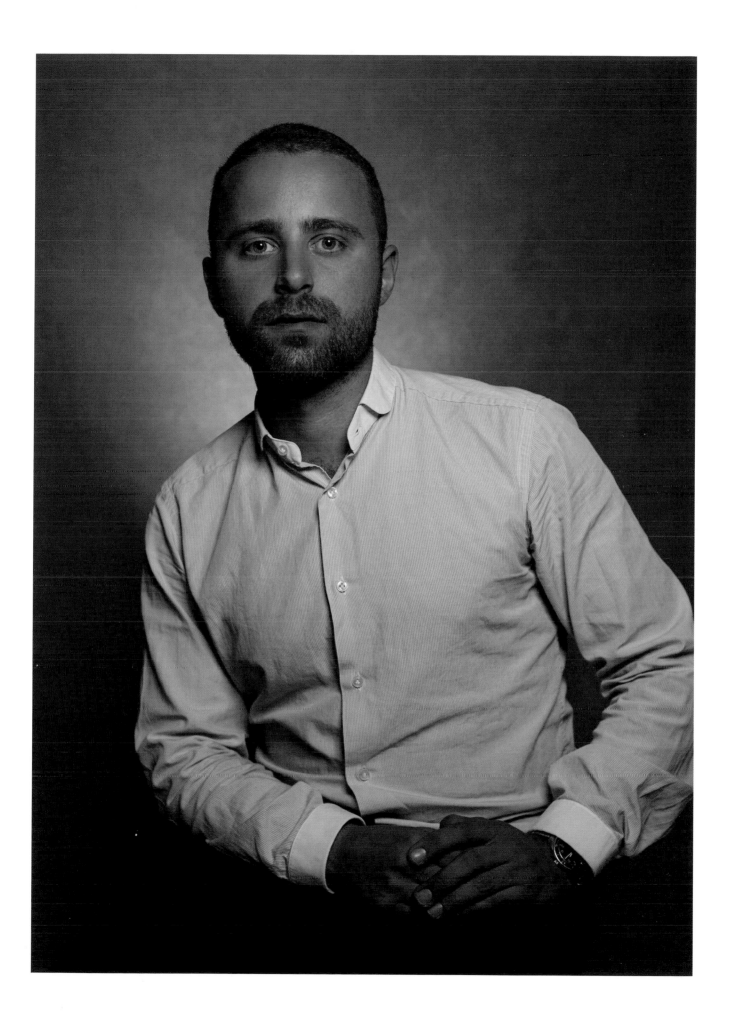

Peter Ivanovich Tolstoy-Miloslavsky
Born 1953

Lives in Denmark
Senior manager in enzymes production

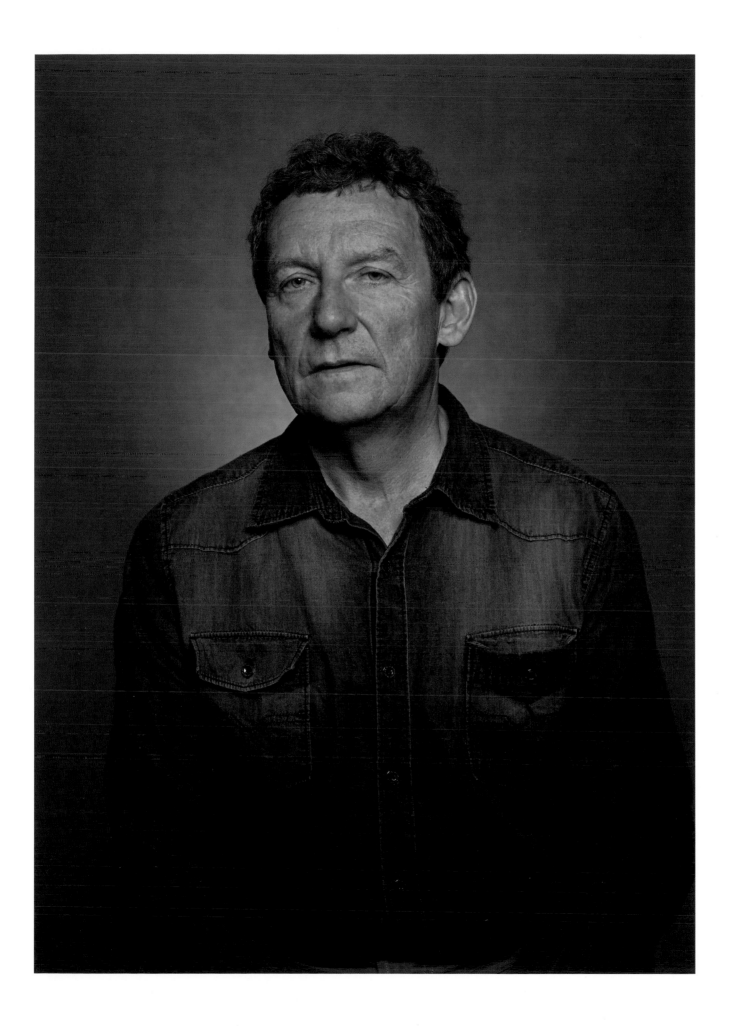

Gisela Tolstoy-Miloslavsky
Wife of Peter Ivanovich Tolstoy-Miloslavsky (see p. 176)
Born 1954

Lives in Denmark

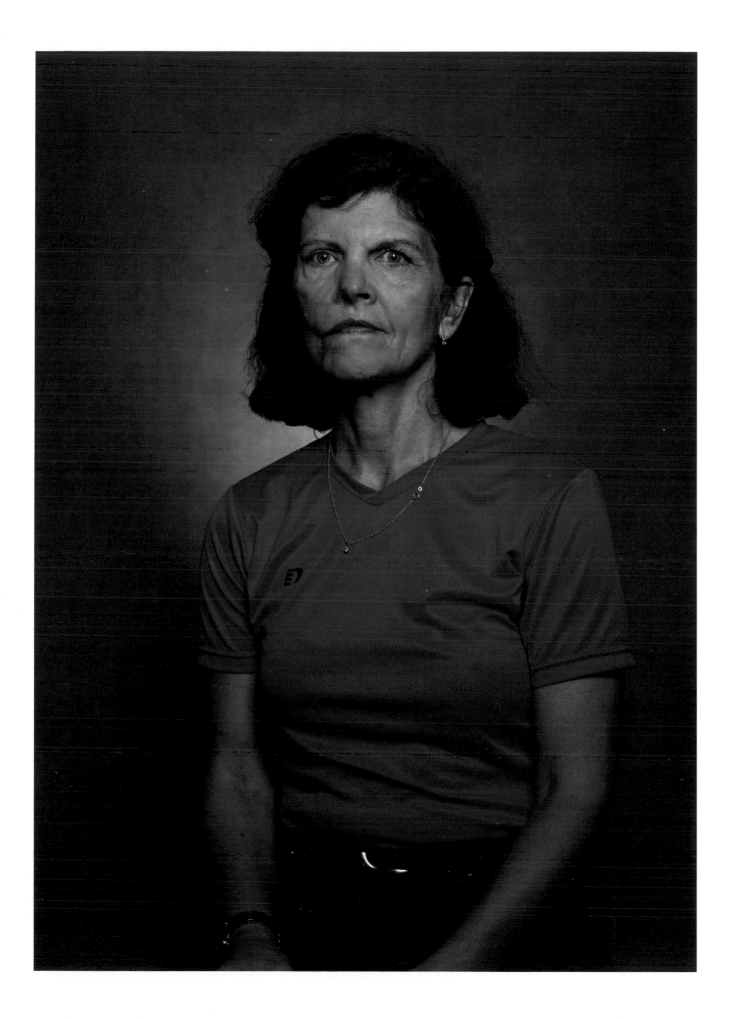

Alexander Ivanovich Tolstoy-Miloslavsky
Born 1956

Lives in Denmark
Pharmaceuticals company director

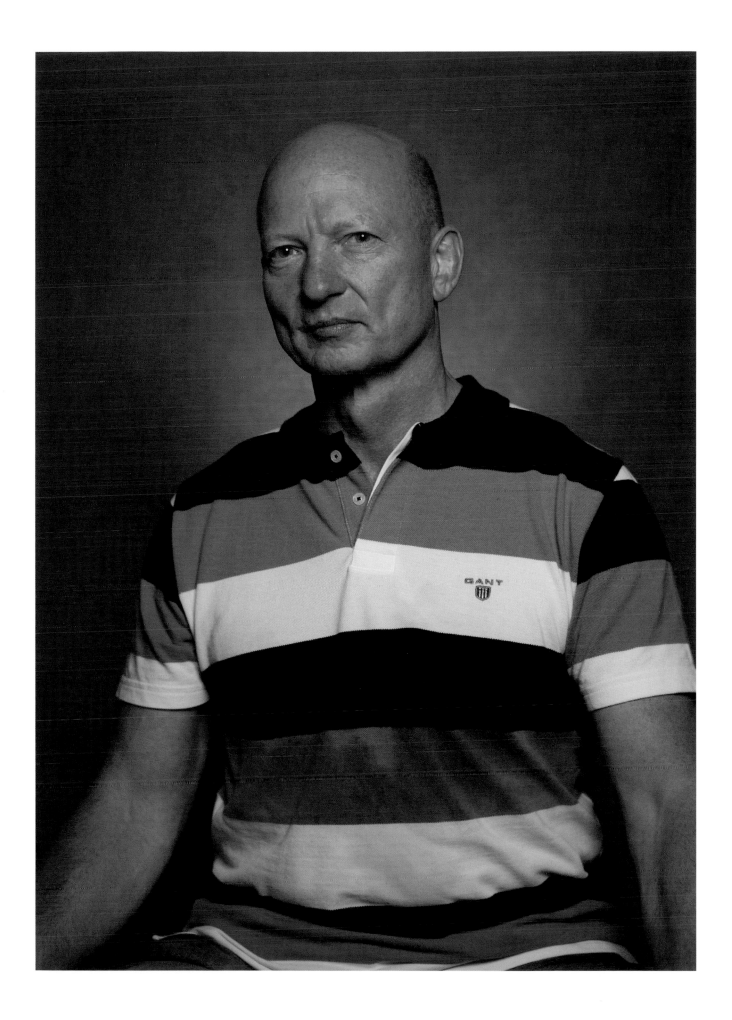

Helen Shennan
Fiancée of Alexander Ivanovich Tolstoy-Miloslavsky (see p. 180)
Born 1965

Lives in Denmark
Medical product innovation manager

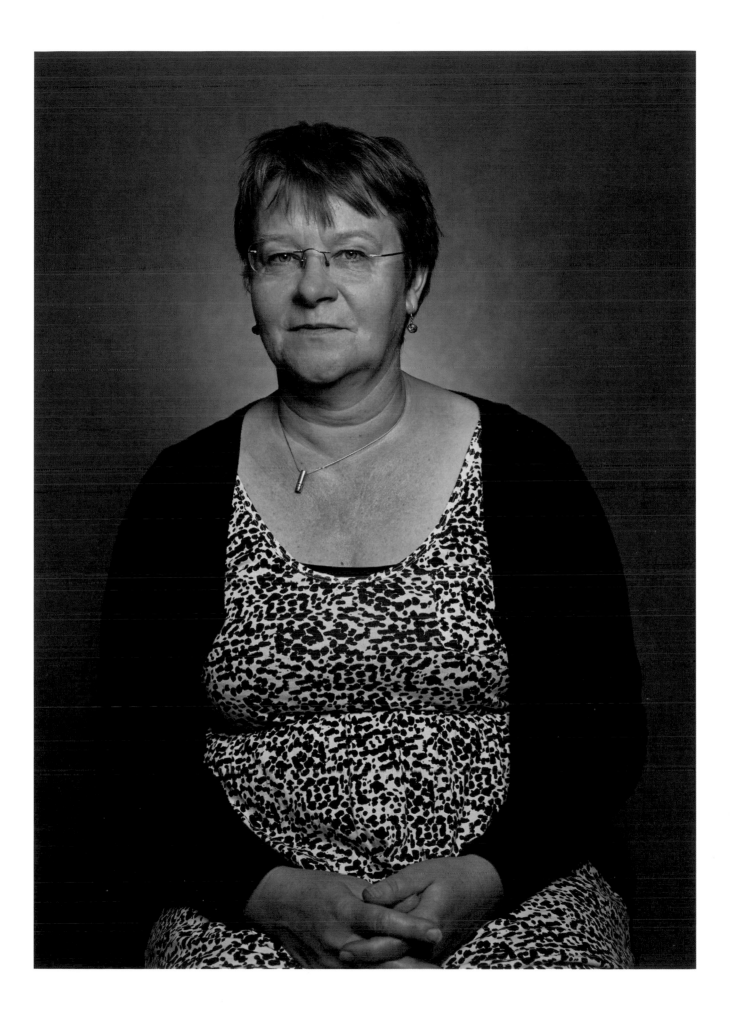

Michael Bucknell
Grandson of Dmitry Mikhailovich Tolstoy-Miloslavsky
Born 1975

Lives in England
Artist

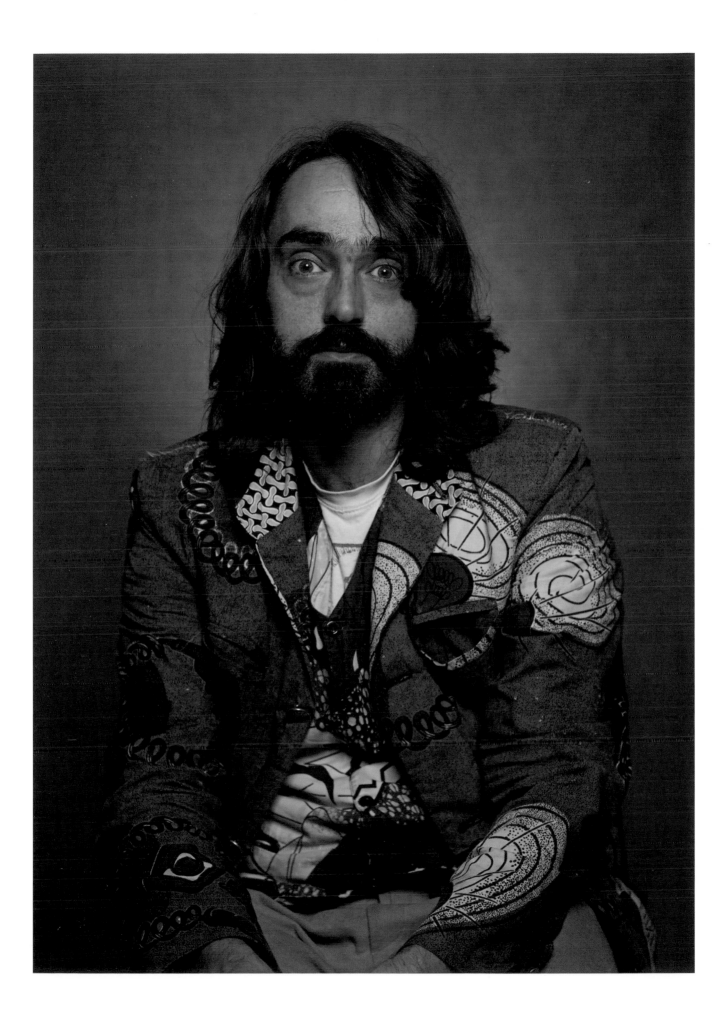

Robert Bucknell
Grandson of Dmitry Mikhailovich Tolstoy-Miloslavsky
Born 1976

Lives in England
Impresario, artist, collector, curator, dealer and author

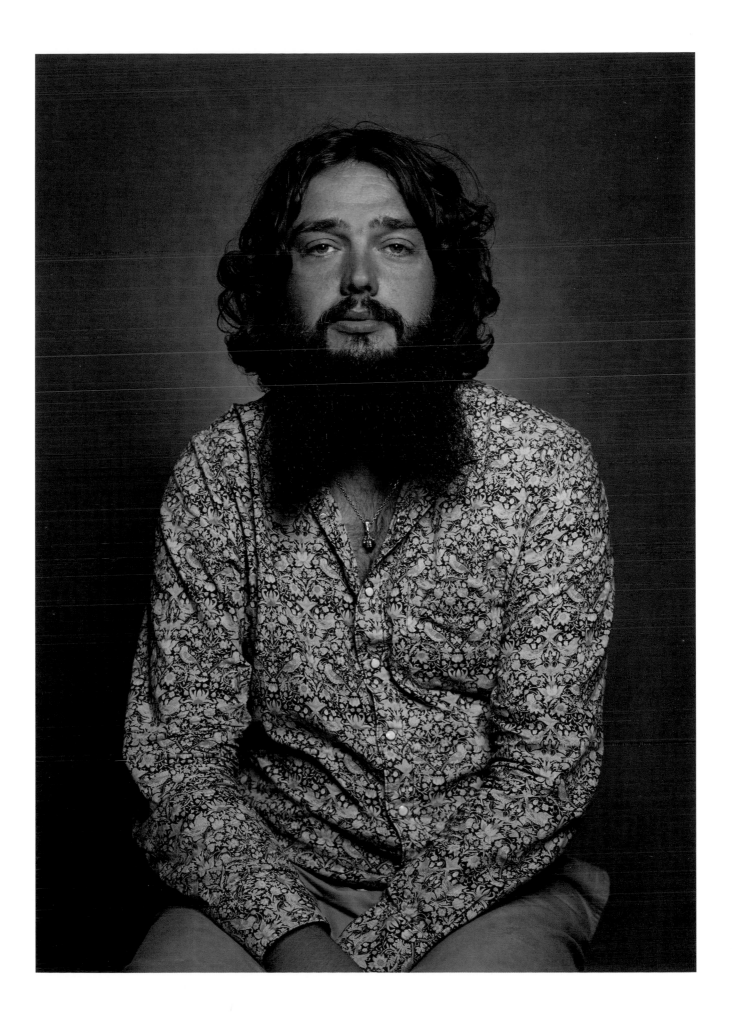

Natalia Igorevna Kutuzova-Tolstaya
Descendant of Field Marshal General Mikhail Illarionovich Golenishchev-Kutuzov
Born 1956

Lives in Russia
Art history teacher

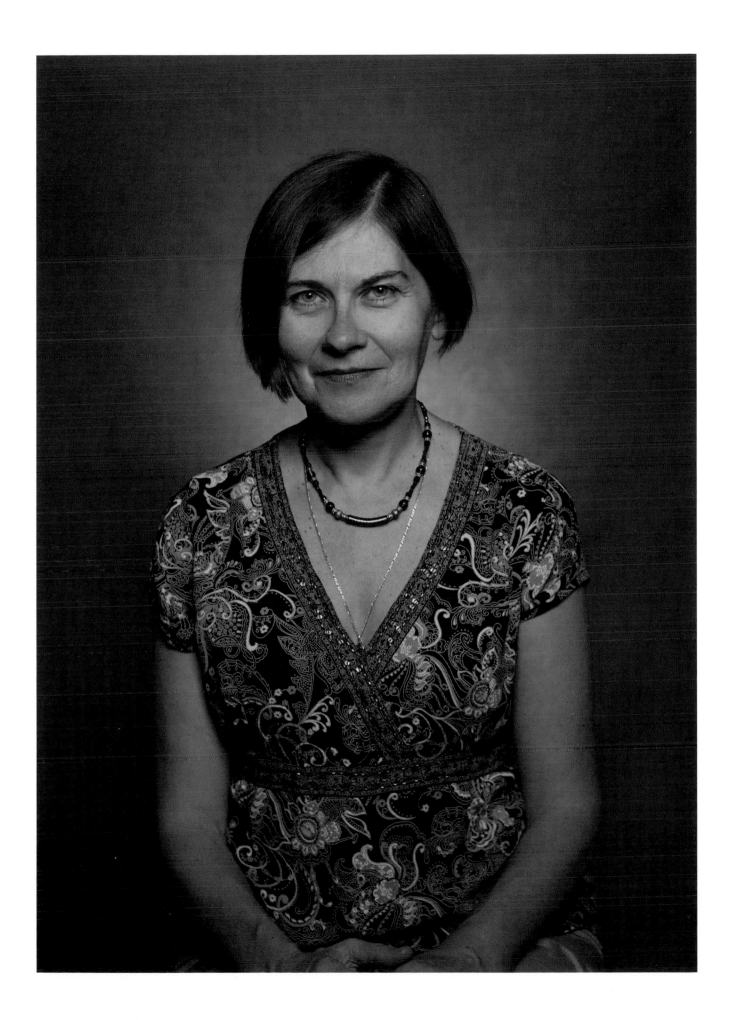

Vera Igorevna Kutuzova-Tolstaya
Descendant of Field Marshal General Mikhail Illarionovich Golenishchev-Kutuzov
Born 1959

Lives in Russia
Architect

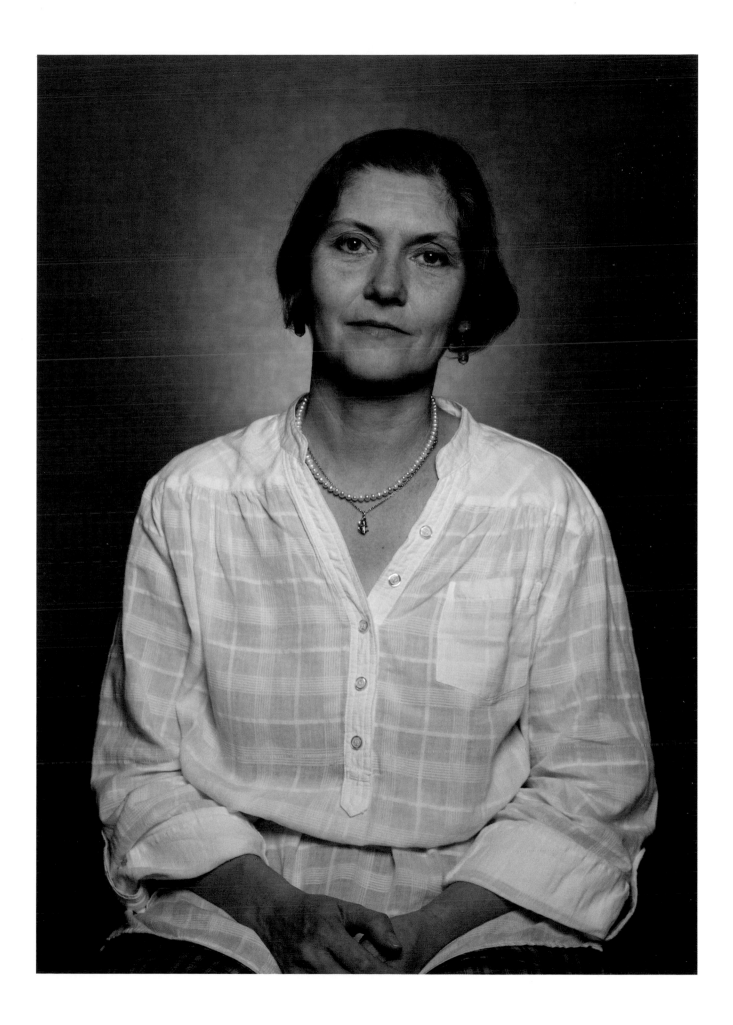

Acknowledgements

I would like to thank the following for their assistance: Vladimir Ilych Tolstoy, Special Adviser on Cultural Affairs to President Putin; at the Yasnaya Polyana Museum-Estate of Lev Tolstoy, Ekaterina Aleksandrovna Tolstaya (Director), Olga Viktorovna Gladun (Curator of the Memorial Library), Tatyana Vasilievna Komorova (retired Curator of the house at Yasnaya Polyana), Nadezhda Valerievna Pereverzeva (Curator of the house at Yasnaya Polyana), Nadezhda Nikolaevna Burova (Head of Administration), Yana Aleksandrovna Bogoslavskaya (Researcher); Michael Xuereb, for retouching; and Ilya Ilych Tolstoy, for his help gathering biographical information. My special thanks go to my father, Andrei Dmitrievich Tolstoy-Miloslavsky, for his invaluable participation in the coordination and compilation of this project.

First published 2015 by Merrell Publishers, London and New York

Merrell Publishers Limited
70 Cowcross Street
London EC1M 6EJ
merrellpublishers.com

Photographs, Preface and captions copyright © 2015 Oleg Tolstoy, except p. 17 (photo copyright © 2015 Igor Tolstoy-Miloslavsky) and back flap (photo copyright © 2015 Michael Bucknell)
Texts by Rosamund Bartlett, Edward Lucie-Smith and Ekaterina Aleksandrovna Tolstaya copyright © 2015 the authors
Design and layout copyright © 2015 Merrell Publishers Limited

British Library Cataloguing in Publication Data. A catalogue record for this book is available from the British Library.

ISBN 978-1-8589-4640-5

Produced by Merrell Publishers Limited
Designed by Nicola Bailey
Project-managed by Claire Chandler

Printed and bound in China

Jacket, front: Family portraits in the study at Yasnaya Polyana, featuring Mikhail Yurevich Alekseev (see p. 112) and Anna Ilyinichna Tolstaya (see p. 52).
Jacket, back (clockwise from top left): Ekaterina Vladimirovna Tolstaya (see p. 62); Christina Leonardovna Albertini (see p. 32); Alexander Petrovich Sarandinaki (see p. 106); Ilya Ilych Tolstoy (see p. 56).
Back flap: Oleg Tolstoy photographs Sergei Petrovich Sarandinaki (see p. 110) inside Tolstoy's 'room of personal effects' at Yasnaya Polyana; photograph by Michael Bucknell.
Page 4: The 'Big Pond' at the entrance to the Yasnaya Polyana estate.

**To my father, without whom this book
would not have been possible**